BONNARD

Colour and Light

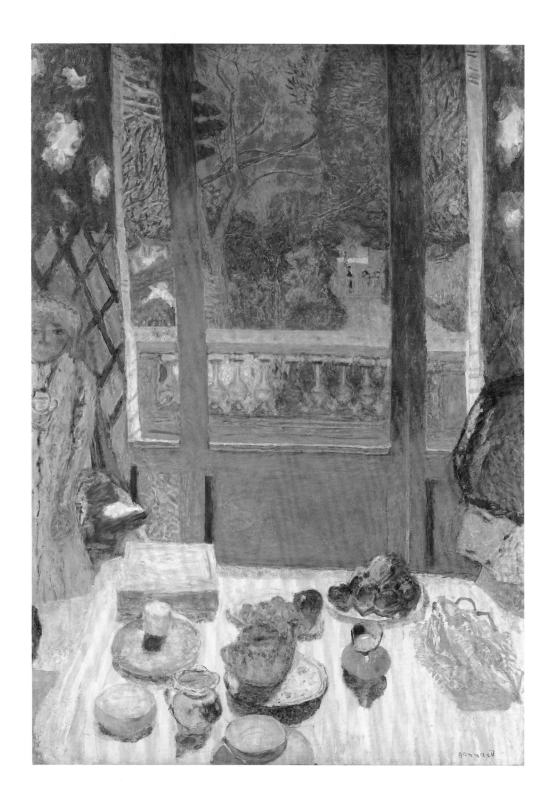

BONNARD
Colour and Light

NICHOLAS WATKINS

Tate Gallery Publishing

Acknowledgements

I owe a great debt to John Gage whose magisterial book *Colour and Culture* set a new standard in the treatment of this most elusive of topics. John Elderfield and Sarah Whitfield kindly read the manuscript and made numerous helpful observations. Timothy Hyman, whose book on Bonnard I read in manuscript, proved a constant stimulus over the last year.

Nicholas Watkins

Sponsor's Foreword

Ernst & Young is delighted to be sponsoring *Bonnard* at the Tate Gallery. Bonnard's reputation as one of the finest early twentieth-century European painters continues to grow, and we are pleased to have an opportunity to bring his work to the wider audience it deserves.

In recent years we have undertaken a variety of successful arts sponsorships. *Cézanne*, also staged at the Tate, attracted 400,000 visitors in Spring 1996 – the best-attended exhibition ever at the Tate Gallery.

Ernst & Young is one of the world's largest firms of business and financial advisors. Sponsorship, with all its educational and cultural advantages, gives us a welcome opportunity to support the wider community that, directly or indirectly, sustains us in our own activities, and we are particularly happy to be associated with what promises to be a highly important exhibition.

Nick Land
Senior Partner, Ernst & Young

Front cover: *The Dining Room in the Country* 1913 (detail of fig.27)

Back cover: *The Bathroom* 1932
oil on canvas 121 × 118.1 (47⅝ × 46½) The Museum of Modern Art, New York. Florene May Schoenborn Bequest 1996

Frontispiece: *Dining Room Overlooking the Garden (The Breakfast Room)* 1930–1
oil on canvas 159.3 × 113.8 (62¾ × 44⅞) The Museum of Modern Art, New York. Given anonymously 1941

ISBN 1 85437 256 4

A catalogue record for this book is available from the British Library

Published by order of the Trustees of the Tate Gallery by Tate Gallery Publishing Ltd, Millbank, London SW1P 4RG

© 1998 Nicholas Watkins

The moral rights of the author have been asserted

Designed and typeset by Caroline Johnston
Printed in England by Balding + Mansell, Norwich

Exhibition sponsored by

ΞII ERNST & YOUNG

Contents

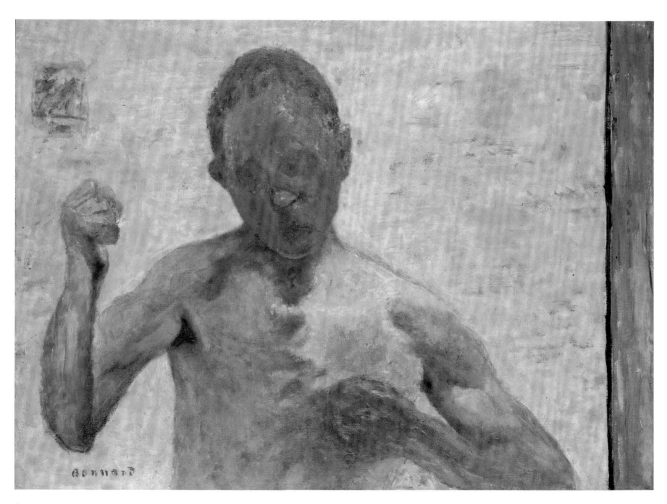

fig.1
The Boxer 1931,
oil on canvas 53.5 × 74 (21⅛ × 29⅛)
Private Collection, Paris

Preface

To think of a Bonnard is to recall a highly coloured emotional atmosphere. The all-pervasive yellow surrounding *The Boxer* 1931 (fig.1) is a colour of light and life, the very substance of vision. It both illuminates the shadowed features of the face in a reddened glow and suggests a deep hurt suffered by an essentially vulnerable personality. The raised hand proffered by the puny figure is both a sign of hopeless resistance and of acquiescence to fate, relieved by the life-giving warmth of the sun.

Bonnard freezes and makes eternal those little incidents that mark the passing of time lived through memories of the comings-and-goings in familiar rooms, Parisian streets and landscapes. His obsessive subject-matter concerns changes in atmosphere and attention: telling gestures, a face glimpsed in a mirror, Marthe, his lifelong companion and muse, caught washing or hovering on the periphery of vision and, above all, the transforming power of light. Past and present are fused in a gently nostalgic vision of the everyday, remembered with all the warmth of approval. A mood both of celebration and loss permeates his art.

Paintings that deal with sentiment, at times bordering on the sentimental, present the familiar in an unfamiliar way. His subjects are not so much placed in space as absorbed within an expressive atmosphere drawn across the surface.

fig.2
Women in the Garden 1891,
oil on paper mounted on canvas,
4 panels, each 160 × 48 (63 × 19)
Musée d'Orsay, Paris

Introduction

You see, when I and my friends adopted the Impressionists' colour
programme in order to build on it we wanted to go beyond naturalistic
colour impressions. *L'art n'est pourtant pas la nature* – We wanted a more
rigorous composition. There was also so much *more* to extract from
colour as a means of expression. But developments ran ahead, society
was ready to accept Cubism and Surrealism before we had reached what
we had viewed as our aim … In a way we found ourselves hanging in
mid air.

<div align="right">

Ingrid Rydbeck, 'Hos Bonnard i Deauville 1937',
Konstrevy, Stockholm 1937, translated by Anne-Marie Kelsted

</div>

Looking back over his long career in 1937, Bonnard clearly saw himself in a tradi-
tion stemming from Impressionism that was concerned with the rehabilitation
of colour as a means of expression. The Impressionist technique of heightened
so-called spectral colour, broken brushwork and pale luminous grounds, evolved
to capture the palpitating play of light on a motif, liberated painting from
chiaroscuro – the convention of organising a picture in terms of tonal divisions
between light and dark – and made possible the consideration of colour as an
expressive medium in its own right. In May 1891, the month after the twenty-
three-year-old Bonnard exhibited for the first time with five paintings and the
four decorative Japanese-inspired panels entitled *Women in the Garden* (fig.2) at the
Salon des Indépendants, Claude Monet enjoyed a highly successful exhibition at
Durand-Ruel's in Paris, featuring fifteen of his recent *Haystacks* series (see fig.3).
Monet's exhibition marked a significant move away from the literal naturalism of
early Impressionism, to achieve a more complex poetic equivalent in paint for the
'experience' of witnessing in nature the changes in mood evoked by time, light
and weather.

It is crucial to bear in mind, though, that Bonnard was at this time avowedly
unaware of Impressionism and found his way as an artist through a combination
of Gauguin and Japanese prints. For Bonnard and his young colleagues such as

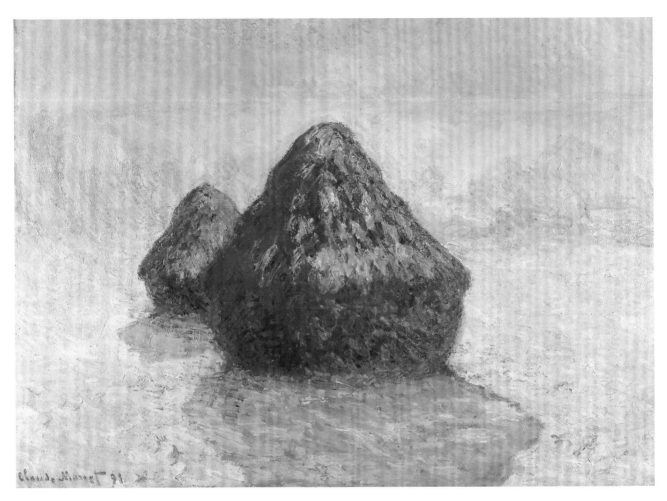

fig.3
Claude Monet,
Haystacks (Snow Effect) 1891,
oil on canvas 64.8 × 92.1 (25½ × 36¼)
National Gallery of Scotland

Paul Sérusier, Maurice Denis and Edouard Vuillard who formed the Nabi group in 1889, Paul Gauguin was a talisman who enabled them to escape the formulae of nineteenth-century academicism and the empirical limitations of naturalism. Inspired like the young Nabis by Symbolist poetry, Gauguin demonstrated that it was possible to think of art as an expressive language that, over and above description, could function through relationships between the very elements of the artistic vocabulary – colour, line and composition – to evoke feeling and thought and to reveal the mysterious nature of human experience.

For Bonnard there was something a little forced about Gauguin's style, with its heavy linear contours and compartmentalised colours, too much the product of a theory, and when he 'discovered' Impressionism in the latter half of the 1890s it came as something of an antidote, as he later told Raymond Cogniat: 'I remember very well that at that time I knew nothing about Impressionism, and we admired Gauguin's work for itself and not in its context. Besides, when we discovered Impressionism a little later, it came as a new enthusiasm, a sense of revelation and liberation, because Gauguin is a classic, almost a traditionalist, and Impressionism brought us freedom.'[1] For Impressionism was sufficiently open-ended for Bonnard to find through it a way of reconciling the aspirations of his formative Nabi years with his gradual evolution of an art based on deeply felt experiences, filtered through memory and expressed by relationships between colour, line and composition within an overall atmosphere of light.

The irony was that Impressionism for Bonnard was both a starting point and a trap, a trap in the sense that the style carried with it the limiting expectations of an established market which led him at times to produce too many superficial canvases. Also, in reverting to and ultimately transforming an overtly outmoded style he abandoned any pretensions to the leadership of the avant-garde. Modern art constituted a reaction against Impressionism, particularly against its followers, epitomised for Picasso, the archetypal twentieth-century artist, by Bonnard. 'Don't talk to me about Bonnard,' he warned Françoise Gilot, and then went on to castigate the way Bonnard built up the surface, 'touch by touch, centimetre by centimetre … a potpourri of indecision.'[2] It was not that Bonnard was hostile to modern developments, it was just that he absorbed what he needed from them on his own terms. His art therefore presents us with the paradox of a major twentieth-century artist who attained his ends through seemingly retrogressive means.

1 Shadowlands

Central to Bonnard's programme to 'go beyond naturalistic colour impressions' was his development of the very traditional academic technique of *clair-obscur* or chiaroscuro, which Impressionism had earlier rejected. It is no exaggeration to say that his expressive art of colour began in darkness.

In a sense Bonnard started from the academic position articulated by Charles Blanc, the former Directeur des Beaux-Arts, in his celebrated *Grammaire des Arts du Dessin*, published in 1867: 'The objective of *clair-obscur* was not just to establish objects in relief but to convey the feeling which the painter wanted to express', and he hailed Leonardo as the first of the great modern geniuses in discovering 'the eloquence of the shadow.'[1] For Bonnard the shadow went far beyond a representational technique. In providing him with the means to loosen the connections between object, image and surrounding space he – like the Symbolist poets – was able to discover his obsessive subject-matter in relationships between things remembered in an atmosphere imbued with feeling and to convey experience in a totally unexpected way. Neither expressionist, nor impressionist, nor realist, his art was born out of an awareness of the contradictions inherent in the relationship between the transience of experience and the permanence of painting, and he floated between both the intimist and decorative aspirations of his early Nabi years. As a determining, metamorphosing entity, without permanence within light, the shadow in itself became a symbol of the transient nature of his art.

Shadows have been an integral part of the history of representation in Western art. Pliny the Elder's *Natural History*, written in the first century AD, recounts the myth of the origin of painting in the outlining of a projected human shadow.[2] From the outset, shadow painting had magical connotations: the magic of resemblance and the magic of substitution. A projected shadow defined a figure through the silhouette and mysteriously communicated the presence of an absent person. Shadows lent credence to the reality of a figure, describing its form in space, and yet were in themselves insubstantial and impermanent. To the

*The Lamp c.*1899 (detail of fig.9)

ancient Greeks the dead existed as shades among shades.[3] Shadows suggested another world, outside the spectator, which nevertheless impinged often unpleasantly on the present.

Leonardo became fascinated by the active power of darkness. In his system, shadows, caused by 'the obstruction of light', lay between light and darkness and played an important role in perspective. He disapproved of harsh disjunctions between light and shadow and developed the *sfumato* technique to dissolve the rigid contours between them in a softly veiled atmosphere of gradated steps.[4] In the seventeenth century Caravaggio reversed Leonardo's achievement and exploited the dramatic power of contrasts between light and dark in his *tenebroso* (dark) style which Rembrandt developed to convey both a physical and a spiritual reality. The heightened colour of Impressionism partly arose out of the concern of the eighteenth-century Enlightenment with coloured shadows.[5] However, it would be wrong to think of the nineteenth century as exclusively a century of light and colour because the tradition of *clair-obscur* continued. Gauguin and the so-called Post-Impressionists, reacting against any too easy notion of painting being about the recording of surface appearances, sought a more profound reality in the dialogue between their sensations, thoughts and pictorial means. Vision was an essentially subjective process which made sense of two-dimensional patterns of light and darkness falling on the retina.

Bonnard's self-conscious exploitation of shadow painting drew on an extensive range of sources, from academic theories, the history of art, Japanese wood-block prints, shadow plays, the theatre, poetry and philosophy to photography. Rather than take these separately, I am going to bring them in where appropriate in the analysis of selected exterior and interior themes.

Bonnard's art began in the transient shadow-patterns formed by people passing along a street or watching a spectacle and in the intimacies enacted between friends, family and lovers within the security of a shadowy interior; two very different worlds, one public, one private, treated in very different ways. Fundamental to both was the concept of drawing as the initial recording of sensations in patterns of light and shadow which were then filtered and flattened through memory in the process of painting.

Exterior patterns and public space

Bonnard's first major multi-figure composition *The Croquet Game* of 1892 (fig.4) was heavily indebted to Gauguin, who suggested a way of dealing with the world in terms of flatness and pattern and also advocated the use of shadow as a substitute for the human figure. In Gauguin's *Vision after the Sermon* of 1888 (fig.5) the conflict between an earthly and a spiritual reality is illustrated in the abrupt division between the congregation, a pattern of Breton women strung along the foreground and the diminutive Jacob and the angel wrestling in an extra-terrestrial red field banked up behind. Gauguin was reported by Emile Bernard to have said: 'instead of a figure, you put the shadow only of the person you have found an original starting point, the strangeness of which you have calculated.'[6] *The Croquet Game* demonstrates Bonnard's response to the Gauguin in terms of broad tonal patterns of light and shadow within the greens of the foliage, rather than bright colour, and with a similar division between his family in the foreground and the visionary apparition of the dancing maidens in the background.

The calculated strangeness of projected shadow people was something that Bonnard was to take up in his street scenes. The employment of shadows in, for instance, *The Cab Horse* of *c*.1895 (fig.6) is worth analysing in some detail. The composition is simply divided in horizontal tonal bands, following as it were Leonardo's advice and beginning with the medium tone, in this case the warm brown of the exposed panel, then the darkest shades, the foreground figures, and finally the principal lights.[7] But everything is not as straightforward as it first appears. The strangeness *is* carefully calculated. The normal hierarchies of vision are reversed. Bonnard later told his nephew Charles Terrasse: 'The vision of distant things is a flat vision';[8] but here the foreground figures are treated as flat shadow silhouettes and the background figures in the light are more roundly modelled. Cast shadow silhouettes are normally projected by a single powerful point light source, but here they are the product of a notionally non-directional source called ambient light which should theoretically reflect diffusely over the whole surface.[9] The drama of the theatre is taken out into the street: the audience in darkness watches a performance in the light. Foregound shadow acts as an interface between individual life and public space.

Bonnard gave fresh impetus to a modern-life city subject promoted by Charles

fig.4
The Croquet Game 1892,
oil on canvas 130 × 162.5 (51¼ × 64)
Musée d'Orsay, Paris. Don Daniel
Wildenstein par l'intermédiaire de la
Société des Amis du Musée d'Orsay

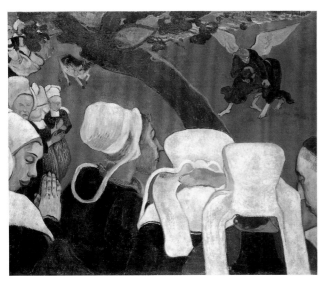

fig.5
Paul Gauguin,
Vision After the Sermon 1888,
oil on canvas 75 × 92 (29½ × 36¼)
National Gallery of Scotland

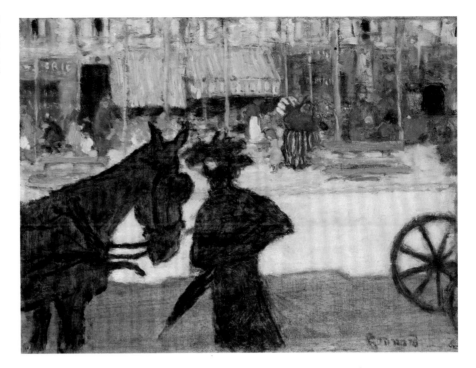

Baudelaire and expressed visually by the Impressionists. In a revealing discussion of Baudelaire's impact on the Impressionists' city subjects, Victor Stoichita provides a plausible account of Bonnard's treatment of the street scenes in terms of shadow. In Bonnard's shadow setting, there is a striking occurrence of two revolutionary concepts: in its snapshot freezing of a shadowy scene the painting represents, firstly, a precise moment in the day and, secondly, the idea of the 'fragment' as part of a continuum, like successive stills from a Zootrope, a contemporary machine activated by hand to give the impression of an animated film.[10] In *The Painter of Modern Life* Baudelaire propounds the idea that: 'To the consummate *flâneur*, the enthusiastic observer, there is nothing more exhilarating than to choose to live in amongst the people – to see the world, to be at the very centre of the world and yet remain hidden from it'.[11] It is not too fanciful to presume that Bonnard's shadow stage represents both the world outside and his concealed presence within it.

Such was Bonnard's commitment to the language of darkness that he advertised the avant-garde magazine *La Revue Blanche (The White Revue)* of 1894 (fig.7), which hoped to include the entire range of contemporary talent in the same way that all the colours of the spectrum are included in white light, with a poster conceived in terms of shadow silhouettes. The situation in the *Cab Horse* is reversed and the actual people in the street 'outside' become the audience looking in at the production of *La Revue Blanche* by an alluring woman staring out from her cape. Bonnard's striking ability to present the everyday street scene as a shadow play may well have been influenced by the actual theatre. The humour in his shadow play appears to have been derived from public entertainments.

Bonnard was closely involved in experimental theatre in the 1890s, contributing to productions by the Théâtre Libre, Théâtre de l'Art, Théâtre de l'Oeuvre, the puppet theatre in the studio of his fellow Nabi Paul Ranson (1861–1909) and Théâtre des Pantins, founded by his brother-in-law Claude Terrasse, Franc-Nohain and Alfred Jarry in 1898.[12] More specifically he was probably influenced by the shadow plays which had been revived at the Chat Noir cabaret, thanks to Rodolphe de Sales and Caran d'Ache, as well as by Japanese wood-block prints, for his presentation of the figures as sharply defined silhouettes filling the format.[13] The vogue for Chinese shadow plays or *ombromanie* lasted up to the invention of photography which perfected the magic lantern to the point where it banished all magic. The last performance was of *Le Juif errant* by Henri Rivière at the Théâtre Antoine in 1898.[14] The shadow plays' double aspect of diabolic and puerile finds an echo in Bonnard's *La Revue Blanche* poster.

Interior darkness and private space

In the transition from street to interior Bonnard adopted a completely different approach to shadow painting. Instead of defining figures as cast shadow silhouettes, shadows formed the surrounding atmosphere within which they existed; the one drew the eye across the surface as a spatial continuum, the other absorbed the spectator into the composition; the one dealt with the spectacle of the everyday life of the street as drama, the other with the drama of the interior world of the artist coming to terms with the cycle of life, infancy, friendships, sex and old age, by observing his family, close friends and above all himself. Shadows

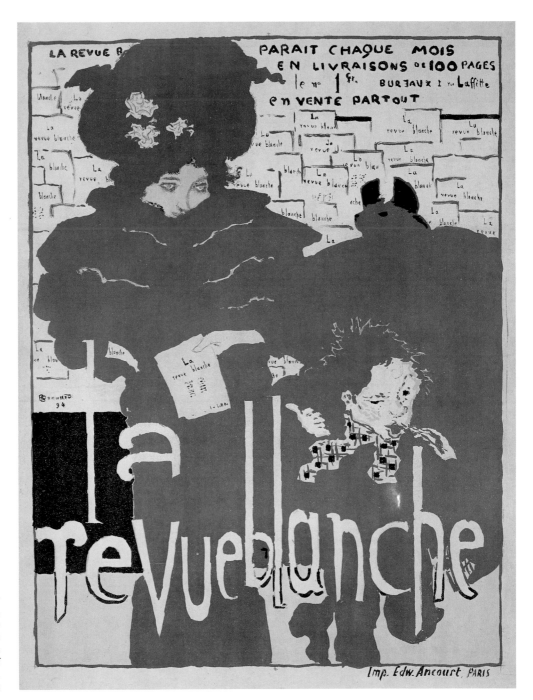

fig.7
La Revue Blanche 1894,
colour lithograph
80 × 63 (31½ × 24¾)
The Metropolitan Museum
of Art, purchase, gift of
Joy E. Feinberg of Berkeley,
California, 1986

tokened depth of thought and feeling; they contained memories, allowed experimentation outside the bright light of public scrutiny and conveyed an awareness of the mysterious nature of existence. In short the shadowed atmosphere became a metonym for consciousness itself. The theatre of experience, mediated through memory, became his subject-matter.

For Bonnard, like Marcel Proust, the memories of time past could only be recaptured through being activated in the present. His family circle was regenerated with the marriage of his sister Andrée to the composer Claude Terrasse on 25 September 1890. From the outset Bonnard made himself part of the new grouping. Their close-knit relationship is commemorated in *Intimacy*, 1891 (fig.8), symbolically bound together by rings of smoke rising up to form part of the wallpaper pattern within the enveloping darkness and with Bonnard's own presence registered at the bottom in the hand holding the pipe. In accordance with academic theory the light source appears from the top left corner outside the painting. Andrée melts into the shadow *contre-jour* and Claude is left to dominate, the centre of attention and its lighting. Bonnard had no children of his own and the Terrasse children, Jean (b.1892), Charles (b.1893), Renée (b.1894), Robert (b.1896), Marcel (b.1897) and Eugénie, known as Vivette (b.1899) became his surrogate family.

In painting his nephews and nieces in the darkened atmosphere of the rooms of the family home, Le Clos at Grand-Lemps in the Dauphinée in which he himself had spent his holidays, he was able to cut back to his own formative experiences. He therefore excluded his brother-in-law from these works. Henry Havard's popular book on interior decoration describes a room's function as 'un repos pour l'esprit',[15] a place of rest for the spirit, but for Bonnard it was much more. The rooms at Le Clos presided over by his grandmother, Mme Frédéric Mertzdorff (1812–1900), were impregnated with memories which framed the present. Bonnard's interior was a place of retreat, nurture and security, a largely feminine world of children and food centred around the dining room table under the protective glow of the central light, a domestic scene recorded in *The Lamp*, c.1899 (fig.9).

In *The Lamp* the dining room table is tilted up towards the spectator and becomes a theatre in the round. The lighting is carefully calculated. Light reveals the objects which create the sensation of depth through their relationships. The lamp is a powerful point source which should project dramatic cast shadows.

fig.8
Intimacy 1891,
oil on canvas
38 × 36 (15 × 14⅛)
Musée d'Orsay, Paris

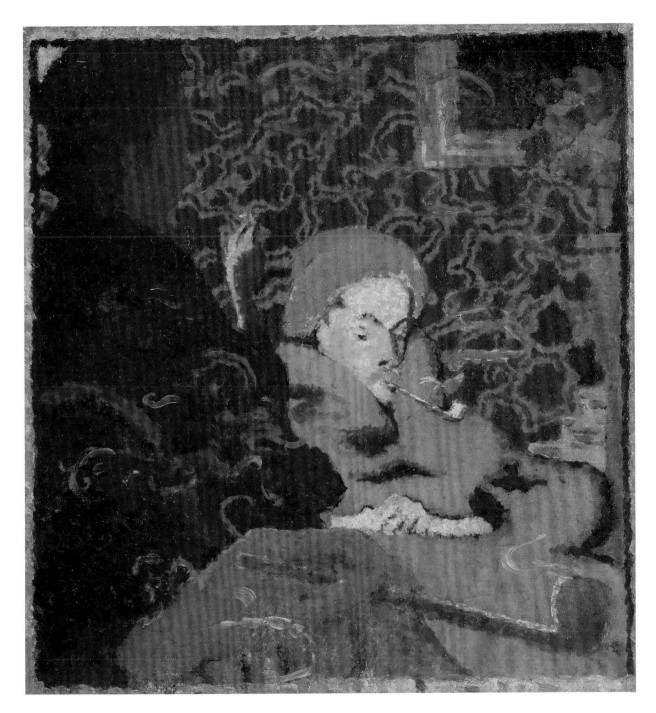

However the function of the cast shadows is not to dramatise the appearance of objects but to enhance the impression of the lightness of the white tablecloth whose reflective surface spreads an even light. Objects vary in illumination according to the attention accorded them. The dark bottles, like shadows, become black holes within light. A plate merges with the cloth as it moves out of contention on the right, whereas the object colour of the red-orange fruit, piled up in the centre of the composition, glows like coals to generate an alternative light source to the lamp above. At the same time the lighting functions symbolically. The three ages of life are realised in relation to the darkness of the shadow. The grandmother, close to death, is becoming a shadow among the shadows, the mother on the left is half way there and the child beside her by contrast stands out as light against the dark.

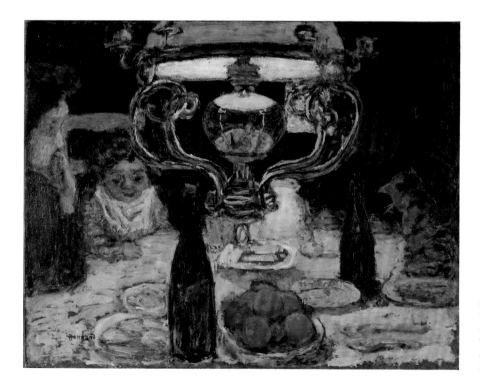

fig.9
The Lamp c.1899,
oil on board 54 × 70.5 (21¼ × 27¾)
The Flint Institute of Arts, Gift
of The Whiting Foundation and
Mr and Mrs Donald E. Johnson

The shadow of desire

In 1893 Bonnard began an affair with a young woman posing as a sixteen-year-old with the name of Marthe de Méligny, though she preferred to be called simply Marthe. In fact her real name was Maria Boursin, and she was twenty-four.[16] Marthe was to remain, through all the difficulties, his lifelong companion and muse, and their liaison developed into a relationship that was to transform his art and life. In a sense Bonnard's pictorial language evolved with his relationship with her and she became his principal subject.

In the young Bonnard's art Marthe suggested sex and within the seclusion of his Montmartre studio, away from the atmosphere of his family home, he was to evolve a shadow language to deal with erotic love. *Woman Pulling on her Stockings* of 1893 (fig.10) catches Marthe, her face screened by loose locks of tumbling hair, putting on her black stocking. Sheet, shift and discarded stocking are crumpled in an erotic shadow pattern of ecstatic squiggles which is taken up on the wall behind. As their relationship deepened and with the added stimulus of the commission from Vollard to illustrate Verlaine's often highly erotic poems *Parallèlement*, published in 1900, which includes six lesbian sonnets along with poems about prostitution and sexual inversion, Bonnard universalised their affair in a remarkably frank series of canvases.

The subject of the fundamental division between the sexes is made concrete in *Man and Woman* of 1900 (fig.11) which is performed as a shadow play projected onto the canvas with a folded screen separating the naked figures of Marthe in the light and Bonnard in shadow. The painting brought up to date the Plinian myth of the origin of painting which by the Enlightenment had come to be regarded as a myth of love.[17] Butades's daughter, in tracing the projected shadow silhouette of her departing boyfriend, preserved him through the image, in the same way that Bonnard preserved the memory of his love for Marthe. The folded screen set up in front of Marthe, posed in the light, serves as a metaphor for the act of painting something as transient as erotic love. After *Man and Woman* the artist's presence – and by extension the spectator's – became transmuted into shadow. The shadows encompassing Marthe splayed out on the bed in *Indolence*, c.1899 (fig.12), suggest possession, both the attentions of a lover and the gaze of a voyeur infiltrating the scene.

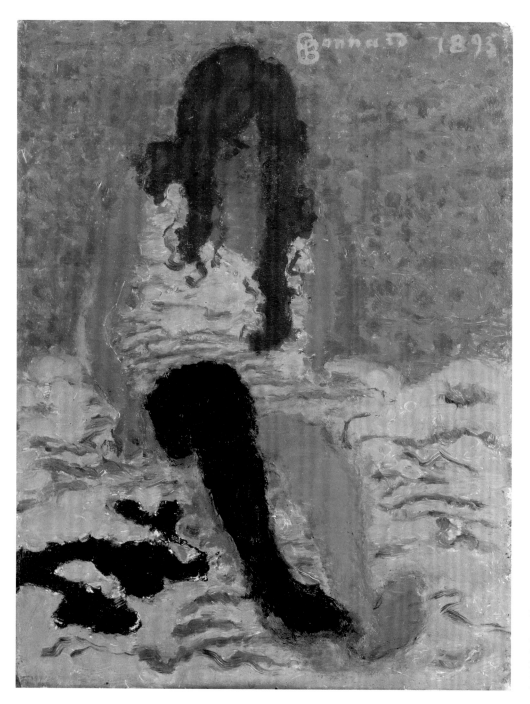

fig.10
*Woman Pulling on
her Stockings* 1893,
oil on board
35.2 × 27 (13⅞ × 10⅝)
Private Collection, courtesy
the Fine Art Society plc

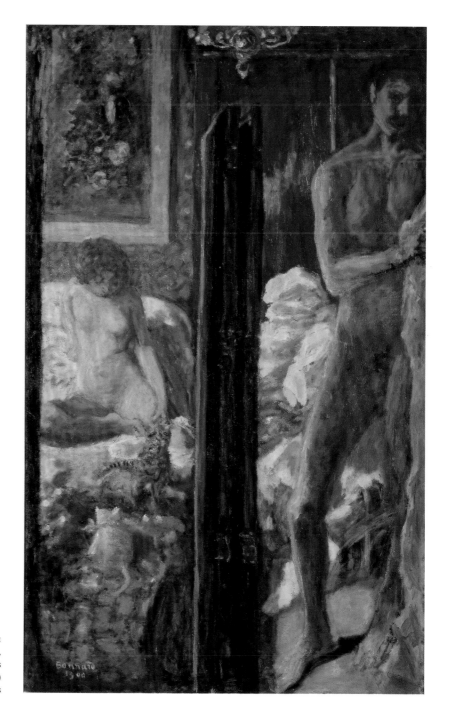

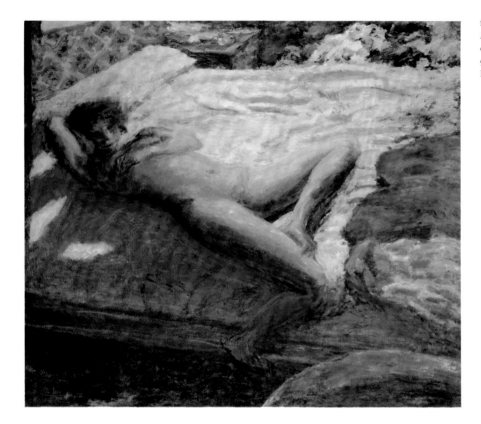

fig.12
Indolence 1898 or 1899,
oil on canvas
92 × 108 (36¼ × 42½)
Private Collection

Photography, that ultimate mechanism of mimesis, played a crucial part in the metamorphosis of Marthe into art. Bonnard photographed her in the nude to sort out the poses and the disposition of the principal masses of light and shade in both paintings and illustrations. The correspondence between photograph and illustration is in some cases close. In the illustration of *L'Eté* (fig.13) he follows the words 'elle en a l'ombre', she is in shadow, only as far as her head is concerned, and uses the shadow to accentuate the lightness of her body as in the frontally lit photograph (fig.14). The idea of the frontally lit nude acting as a light source was to become a feature of his later paintings of Marthe in the bath.

Just as Bonnard found his own formative memories returning in painting his nephews and nieces, so too did he reactivate the erotic passion of his first encounter with Marthe in at least two serious affairs with much younger women,

Lucienne Dupuy de Frenelle in 1916–17 and from about 1917 Renée Monchaty, known as Chaty, both of whom modelled for him. He spent two weeks with Chaty in Rome in 1921 and his subsequent return to Marthe may have led to Chaty's tragic suicide in 1924. But there is a crucial difference between his paintings of Marthe and of these other women. Bonnard's paintings are not so much an emotional diary as the recapturing of past intimations of happiness, *un rêve de bonheur*. The bath paintings were exclusively Marthe's preserve. The transition to a painting of light was a move towards idealisation; erotic passion became sublimated in the golden glow of remembrance.

Photography, which had helped fix the image of his first encounters, was abandoned after 1916. Bonnard included both Marthe and Chaty together in *Young Women in the Garden* of 1923 (fig.15), a painting which, significantly, he reworked in 1945–6, some three years after Marthe's death in 1942. The relationship between the two women in the painting is revealing. Chaty is in the centre

fig.13
L'Eté, a page from Paul Verlaine, *Parallèlement*, 1900, colour lithograph
30.5 × 25 (12 × 9¾)
The Board of Trustees of the Victoria and Albert Museum

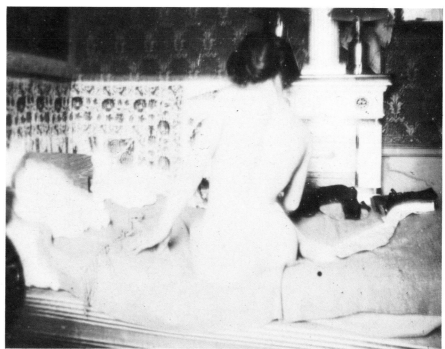

fig.14
Marthe photographed by Bonnard, *c*.1899–1900
Musée d'Orsay, Paris

fig.15
*Young Women in the Garden
(Renée Monchaty and Marthe
Bonnard)* 1923 (reworked 1945–6),
oil on canvas 60.5 × 77 (23⅞ × 30⅜)
Private Collection, USA, courtesy
Richard L. Feigen & Co, New York

bathed in the golden light of nostalgia and Marthe is the jealous presence in the bottom right-hand corner in shadow.[18] Without obstructing a light source she is again presented in *Table in Front of the Window* of 1934–5 (fig.16 and frontispiece) as a shadow. Beset by chronic illness Marthe had become a shade among the shades, but the memory of her youthful body lived on in some of the greatest paintings of the nude in Western art.

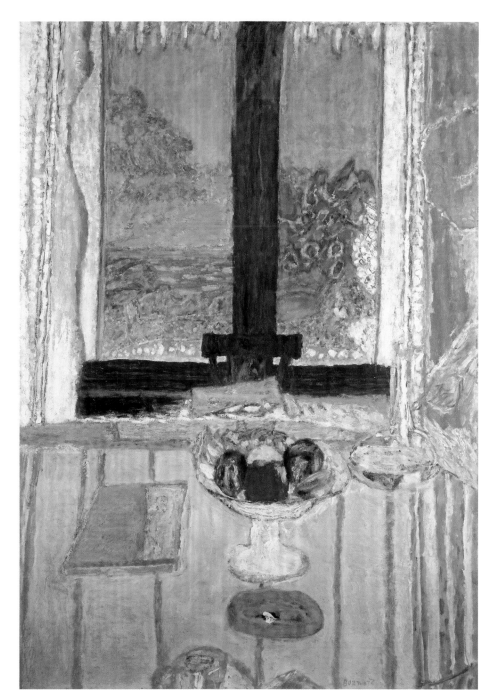

fig.16
Table in Front of the Window 1934–5,
oil on canvas 101.5 × 72.5 (40 × 28½)
Private Collection

2 Decorative Colour

It could be argued that Bonnard's commitment to shadow painting precluded his adherence to the Nabis' belief both in the autonomy of a work of art as a decorative object and in the expressive power of flat planes of heightened colour. After all, by 1899 Maurice Denis felt that the Nabis had split into two distinct factions, the one, featuring Bonnard, Edouard Vuillard and Vallotton, characterised by sombre palettes and subjects drawn from life, appealing to the *gout sémite* (Jewish taste), and the other with Ranson, Sérusier and himself, adopting a symbolist approach, based on intellect, clear outlines, bright colours and subjects drawn from history, appealing to the *gout latin* (Latin taste), implying the classic, Mediterranean and by inference Catholic.[1] Much as Denis's distinction may have resulted from anti-semitism and a need to define Frenchness at the time of the Dreyfus case, it nevertheless highlighted a fundamental difference in approach.

Bonnard himself recognised a division between tonal painting and the flat bright colour of decorative painting, *peinture décorative*, and placed it in the much wider context of the opposing traditions of Western *clair-obscur* and the oriental.[2] In locating the origins of the appreciation of pure hues in the Orient, Bonnard was following a well-established tradition in the West.[3] It was not that he denied the constructional and expressive power of pure colour, he just wanted to avoid fixed systems and reconcile colour with light in an art based on *sensations* and feelings, both for his subject matter and his pictorial means. The originality of his approach came with his reversal of the traditional academic hierarchy which assigned to drawing the mental, organising principle, and sensations to colour. According to Bonnard: 'Drawing is sensation. Colour is reasoning'.[4] Shortly before his death, when requested by the magazine *Comoedia* to say something about contemporary art, Bonnard identified himself with 'The painter of feeling, outside fashion, less definite about his means and no longer afraid to reattach himself to the *clair-obscuriste* and analytic tradition'.[5]

The Dining Room in the Country 1913
(detail of fig.27)

Colour and decoration

Much as Bonnard chose to see himself as 'the painter of feeling', he still felt it necessary to define and defend his position in opposition to that of the decorative painter. While this was in part an attempt to establish his own territory in response to the challenge of his friend and close contemporary Henri Matisse, it also exposed the fundamental divide in his own art between intimism and decoration. Decorative painting is a fundamental aspect of Bonnard's colour and therefore requires defining.

By 'decorative' Bonnard and the Nabis meant the pictorial autonomy of a work of art as a decorative object. Denis's famous 'Définition du néotraditionisme', published in the review *Art et Critique* in 1890, stated: 'Remember that a picture, before being a war horse, a nude woman or some anecdote, is essentially a flat surface covered with colours and assembled in a certain order.' This carried with it the idea that colour was an autonomous expressive entity in its own right that, in addition to representing a subject, could communicate thought and feeling. Gauguin's art with its unprecedentedly flat bright colour raised the scale and provided a raw and exciting catalyst for the young Nabis; his precise words to Sérusier were copied down by Denis: 'What colour do you see that tree? Is it green? Then use green, the finest green on your palette. And that shadow? It's blue, if anything? Don't be afraid to paint it as blue as you possibly can.'[6] The use of flat bright colour was akin to a return to the directness and moving simplicity of more 'primitive' art forms which were not bound by any distinction between painting and decoration. The wish to break down the barrier between painting and the decorative arts became a feature of Bonnard's and the Nabis' artistic programme. Most notable among Bonnard's first exhibited paintings at the Salon des Indépendants of April 1891 were four Japanaese-inspired decorative panels, now known as *Women in the Garden* (fig.2), which he originally envisaged as being hung together as a screen.

In addition, decorative painting was seen as a primary objective by modern painters seeking to escape the limitations of small-scale easel painting and find a new socially responsible role for their art. Although Bonnard pioneered the subject of the intimist interior, it was Vuillard who developed it in large-scale decorations. According to Gloria Groom, Vuillard's great contribution was to forge

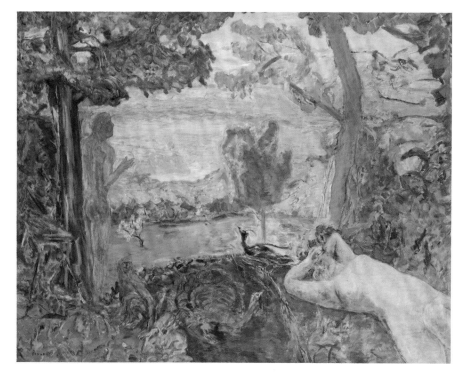

out of everyday subject-matter a novel genre of mural art appropriate to the modern interior, harmonising with the decorative ensemble and yet complete in itself, which appealed to the mobile lifestyle of his patrons. His decorative panels were more temporary wall hangings than permanent murals inseparable from the architectural setting.[7]

Bonnard's decorative schemes combined the everyday with both classical and oriental sources. By 1906 the intimist style was no longer fashionable, and by the Salon d'Automne of 1908 *peinture décorative* had become accepted as a new form of modern art. The pendulum of public taste swung from intimism to classicism. Bonnard's *The Earthly Paradise* of 1916–20 (fig.17), which formed part of a cycle of four decorative panels commissioned from his dealers the Bernheim family, presents a complex fusion of the temporal with the timeless, a contemporary landscape with the subject of the classical Golden Age relocated in the Garden of Eden. It was begun during the First World War. Deep shadows have fallen across the foreground. The sun is setting on an earthly paradise.

From the outset of his career Bonnard appreciated that colour schemes were bound by cultural perceptions. He chose a pink for *Parallèlement* (fig.13) to communicate an essentially Rococo vision of nudes softly outlined in red chalk. An even golden glow on a hot landscape could suggest a classical Golden Age.

In summary, *peinture décorative* had profound implications for Bonnard's colour practice. It led to his consideration of a painting as an affective decorative object that could communicate feeling through colour, line and composition. It reinforced the notion that colour was an expressive language with its own structural imperatives; that a painting began in the experience of the actual colours arranged on the palette, like the notes of a musician's instrument; that colour determined the mood of a composition; that for colour to have an impact the areas of colour had to be simplified, enlarged and then brought up to the picture plane; and finally, that through relationships between colour areas lay the possibility of creating a non-mechanical pictorial space.

Japanese wood-block prints and colour lithography

Gauguin may have first stimulated Bonnard's interest in pure hues but Japanese wood-block prints showed him how to think in terms of colour. Such was his enthusiasm for all things Japanese that he became known as 'le Nabi très Japonard'. Intimist shadow painting spoke of an interior world whereas Japanese wood-block prints opened Bonnard's art out to the colour and vitality of contemporary life and helped bridge the gap between *peinture décorative* and reality, and at the same time, counter the slightly maudlin, backward-looking nature of Gauguin's Symbolism, as he explained to Gaston Diehl in 1943: 'I covered the walls of my room with this naive and gaudy imagery. To me Gauguin and Sérusier alluded to the past. But what I had in front of me was something tremendously alive and extremely clever.'[8] There was enough stimulus in Japanese prints to last Bonnard a lifetime. A print by Hiroshige joined reproductions of Gauguin's *Vision After the Sermon*, Seurat's *Bathers at Asnières* and paintings by Renoir, Vermeer and Picasso on his studio wall of fame, his ancestor wall, at Le Cannet photographed by Alexander Liberman in 1955 (fig.18).

The immense survey exhibition of some 725 Japanese wood-block prints and 421 illustrated books at the Ecole des Beaux-Arts during April to May 1890 came

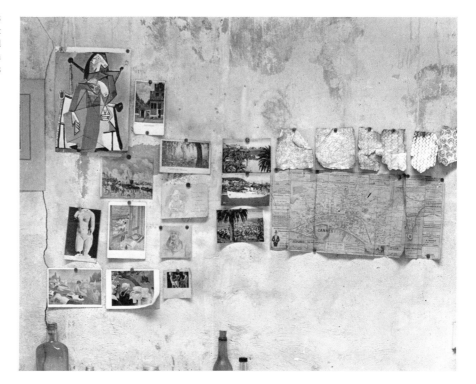

to Bonnard as a revelation: 'I realised that colour could express everything, as it did in this exhibition, with no need for relief or texture. I understood that it was possible to translate light, shape and character by colour alone, without the need for values.'[9] From Japanese prints Bonnard learned that colour patterns could be every bit as eloquent as shadow patterns. He evolved a language of pattern in which shape and colour changed with content. The dominant yellow, dynamic flowing arabesque and crackling energy of the patterned analyses of hair and overflowing glass in *France-Champagne* of 1891 (fig.19) suitably advertise the product. The slower patterns of yellow dots of light percolating through the russet-red falling leaves of the right-hand panel of *Women in the Garden* of 1891 (fig.2) conjure up the sensation of autumn. The squared red pattern of the mother's dress enclosing the baby in *Family Scene* of 1893 (fig.20) connotes protective warmth and stability.

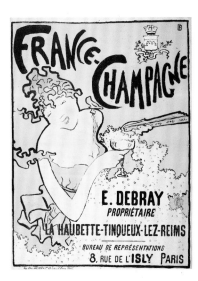

fig.19
France-Champagne 1891,
lithograph 78 × 50 (30¾ × 19¾)
Jane Voorhees Zimmerli Art Museum,
Rutgers, the State University of
New Jersey. Gift of Ralph and
Barbara Voorhees

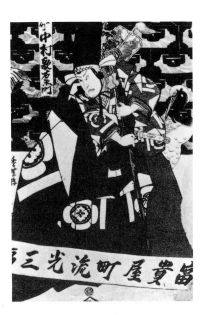

fig.21
Utagawa Kunisada, *Nakamura
Utaemon in a Scene from the Kabuki*,
before 1861, colour woodcut
Private Collection

fig.20
Family Scene 1893,
colour lithograph
31.2 × 17.7 (12¼ × 7),
from an album of
L'Estampe originale
Metropolitan Museum
of Art, Rogers Fund, 1922

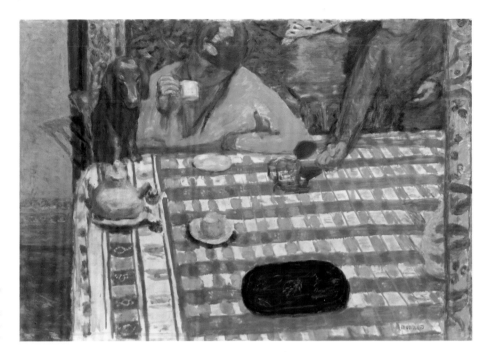

fig.22
Coffee 1915,
oil on canvas
73 × 106.4 (28¾ × 41⅞)
Tate Gallery

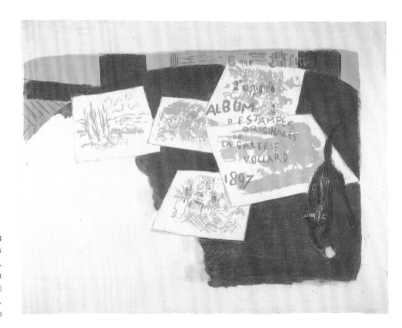

fig.23
*Album d'estampes originales
de la Galerie Vollard 1897,*
portfolio cover, lithograph
71.1 × 92.7 (28 × 36½)
The Art Institute of Chicago.
John H. Wrenn Fund 1960

Bonnard came to appreciate that colour had to be restricted for it to be effective in terms of mood and structure. From Kunisada's *Nakamura Utaemon in a Scene from the Kabuki* (fig.21), which he owned, and other prints, Bonnard discovered in addition that patterns of colour could generate energy. A concentrated burst of energy could find a response in an area of expansion. Human interest could be made to compete with colour pattern for attention. Negative shapes could play as important a part as positive shapes. Background patterns could play an active role in defining foreground content and *vice-versa*. The employment of the vibrant energy of gingham cloth became one of Bonnard's signature themes (see fig.22).

He went on to develop a novel conception of mobile pictorial space which went beyond the play between surface and depth to suggest space in the transition from one colour area to another, around the surface and in and out of depth.[10] This is illustrated in the portfolio cover *Album d'estampes originales de la Galerie Vollard 1897* (fig.23), where the sensation of space is defined through tracing the passage of the cat across the surface in the pattern of the prints displayed in a jerky sequence of overlapping rectangles. He was finally able to achieve the effect where instead of looking *at* the stage behind the picture plane we are made to feel *in* it, scanning the space around us to give the totality of what we see on entering a room.

The practice of 'wrapping' a painting around space in a sequence of rectangular divisions, which were then flattened out across the surface, came from his involvement with making Japanese-inspired screens. In the highly ambitious *White Interior*, 1932 (fig.24) the two sides of the small sitting room of Le Bosquet, his home at Le Cannet, enclosing the bowed figure of Marthe, are opened out across the surface in screen-like units.

The language of colour

Much as Bonnard distrusted theory, his belief that 'colour has just as strong a logic as form' derived from notions about colour current at the end of the nineteenth century. Seurat, the inventor of Neo-Impressionism, in his brief career did more than any other painter to propound the idea that colour was a language with its own grammatical structures which could be taught like music. His disci-

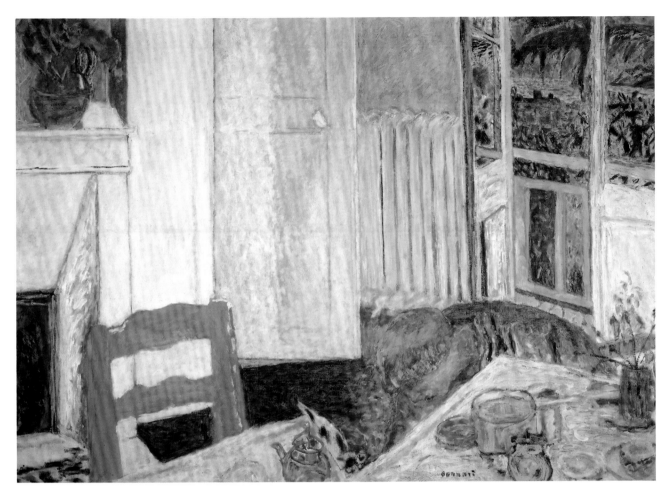

fig.24
White Interior 1932,
oil on canvas
109 × 162 (42⅞ × 63¾)
Musée de Grenoble

ple Signac wrote *D'Eugène Delacroix au néoimpressionisme*, which was published in three instalments in the May to July 1898 issues of *La Revue Blanche*, to maintain interest in Neo-Impressionism. His text served its purpose, though not always in a way that he approved, for it provided the aspiring colourist with a historical rationale and a coherent body of theory seemingly based on scientific law.

The main contribution of the Neo-Impressionists to an art of colour was the establishment of a method of structuring colour in a simple system of colour contrasts plotted on a colour circle. Their theory, that is to say Seurat's 'scientific

fig.25
Michel Eugène
Chevreul, plate from
Chromatic Circle of Hues,
first published in 1839

method', was a confusing amalgam of contemporary ideas on colour and often outmoded information drawn from sources such as Chevreul, the most celebrated colour theorist of the nineteenth century for artists and designers, that Seurat adapted to suit his own essentially poetic vision. In Chevreul's *Chromatic Circle of Hues* (fig.25), illustrated in his book published in 1839, the three pigment primaries, red, yellow and blue, were mixed to give the three secondary colours, orange, green and violet.[11] These six colours, equally spaced around the circle

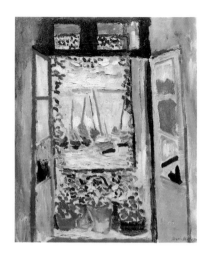

fig.26
Henri Matisse,
The Open Window, Collioure 1905,
oil on canvas 52.7 × 46 (20¾ × 18)
From the collection of
Mrs John Hay Whitney

with the complementaries opposite each other, provided the basic framework within which further subdivisions could be made. Hermann von Helmholtz in *Handbook of Physiological Optics*, published in 1867, undermined the whole concept of primary colour on which Chevreul's circle was based by distinguishing between the additive light primaries, red, green and blue, and the subtractive pigment primaries, red, yellow and blue. Seurat absorbed Helmholtz's ideas from Rood's *Modern Chromatics*, published in 1879,[12] but his colour practice still owed a considerable debt to Chevreul. The essential point was that Chevreul provided the artist with an easily workable system for attaining colour harmony through balancing complementary contrasts plotted on the colour circle, for example, a red area against a green area, or for effecting a gradual transition between the two by moving round from one to the other through a sequence of intervening colours. Therefore the colour circle became for the painter an abstract scale, seemingly based like the musician's scale on scientific law, with which to compose in colour as an expressive medium in its own right.

Although Matisse, under the influence of Van Gogh and Gauguin, led the way in the reaction against Neo-Impressionism in his archetypal *fauve* style of the summer of 1905 at Collioure (see fig.26), he nevertheless recognised in it the basis of his organisation of colour. While Bonnard was never as extreme as Matisse in the use of flat bright decorative colour, he recognised that Fauvism had redefined the language of colour and had introduced a new psychological understanding of a painting as the outcome of a process of reactions and adjustments to the actual colours placed on the canvas surface. 'If one just has a colour to start out from', Bonnard told Ingrid Rydbeck, 'then one builds the whole painting round it. Colour has just as strong a logic as form.'[13] Matisse tended to favour bold contrasts, while Bonnard on the whole perfected extremely subtle transitions across the surface within a light-filled atmosphere.

Bonnard's colour, therefore, must be seen in the context of an evolving preoccupation with colour as a language embedded in culture. Symbolism, which originated in poetry, had opened up painting to the concept of art as an expressive language and around 1913 it was painting in turn which challenged poetry to take on ideas which had developed from Fauvism and Cubism. The mood changed from the slightly maudlin, self-absorbed atmosphere of lost souls facing death to a more robust preoccupation with an expanded consciousness of coloured light

functioning autonomously in time and space. Few juxtapositions illustrate this change more graphically than that between Stéphane Mallarmé's poem *Les Fenêtres* (*Windows*) and Guillaume Apollinaire's *Les Fenêtres*. Mallarmé, who did more than any other poet to set Bonnard's artistic agenda in the 1890s, describes in very generalised terms the actions of a dying man in a fetid hospital who, desperate to see sunlight on the stones outside, presses his face against the window 'which a bright lovely sunbeam wishes to bronze'.[14] Apollinaire's poem, on the other hand, which was inspired by what he christened Orphism, Delaunay's highly coloured version of Cubism which he developed in his *Window* series, begins with 'From red to green the yellow fades' and ends with 'The window opens like an orange / The beautiful fruit of light'.[15] Such an account of the transition of the colours round the colour circle within light would have been inconceivable without a contemporary knowledge of the ways colour was being discussed in the studios of the avant-garde.

In *The Dining Room in the Country*, 1913 (fig.27), the first masterpiece of his maturity as a colourist, Bonnard similarly moved from the shadowy windowless interiors of the 1890s to a preoccupation with windows as metaphors for the paradoxical nature of an art of colour functioning between representation and abstraction within light. A window, like a painting, is both an opening and a barrier, a three-dimensional view and two-dimensional object. The composition turns around the fulcrum of the table from interior to exterior, from red to green. The open door and windows invite the spectator into the composition and at the same time flatten form in an interwoven network of abstract colour patterns across the surface.[16]

Palette, technique and working methods

In *D'Eugène Delacroix au néoimpressionisme* Signac charts the progressive lightening of the palette from Constable, Turner and Delacroix to Impressionism and then Neo-Impressionism. The Impressionists reduced Delacroix's palette to seven or eight colours close to the spectrum and, according to Signac, achieved in the North landscapes more luminous than the oriental scenes of Delacroix: 'The whole surface of a painting radiated the sun; the air flowed round it; the light enveloped, caressed, irradiated the forms, penetrated everywhere, even into

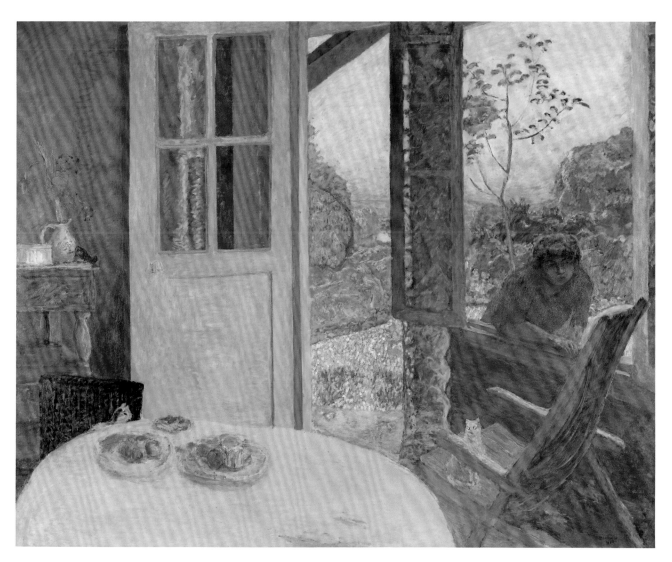

fig.27
The Dining Room in the Country 1913,
oil on canvas 164.5 × 205.7 (64¾ × 81)
The Minneapolis Institute of Arts,
John R. Van Derlip Fund

the shadows which it illumined.'[17] The description hardly fits Monet but it established a virtual programme for Bonnard.

The Neo-Impressionists further systematised the Impressionist palette, but for Bonnard, as for Matisse, painting was partly an empirical business. Both artists were therefore reluctant to be tied down to any prescriptive theory. In a letter to Bonnard of 28 January 1935 Matisse condemns theory as 'something a little sterile and limiting'. In his reply of 1 February 1935 Bonnard agrees that 'the only solid ground for the painter is the palette and the tones'.[18] For Bonnard a palette did more than establish a colour scheme and an overall tonality of a painting; it was in a sense an embryo painting. Pictorial ideas would develop out of his responses to the actual colours put down on the palette. Accounts of Bonnard's working methods vary in detail but all are in agreement that he divided the colours between warm and cool. According to his nephew Charles Terrasse, from the mid-1920s he kept a warm and a cool palette and mixed the colours for each on a separate plate, allowing the successive layers of crusty paint to accumulate suggestively. On a studio visit in 1943 André Giverny noted that he kept a separate plate, an improvised palette, for each painting. 'Why destroy a series of ideas which could be useful?', Bonnard observed.[19]

In his selection of colours Bonnard did not adhere to the Neo-Impressionist prismatic palette systematically set out in the sequence of the spectrum. Such was his evolution from shadow painting that he would for instance use black which, with the exception of Renoir and Cézanne, had virtually disappeared from the Impressionist palette after the mid-1870s, to accentuate a strategically placed object and at the same time establish the darkest note in the tonal scale. In *The Open Window* of 1921 (fig.28) the black cat in the right-hand corner, the black accent on the chair on the left and the blackness of the rolled-up blind shutting down the composition at the top provide a stable internal framework for the play of the vibrating black rhythm in the tree trunks outside. In *The Table*, 1925 (fig.29), the blackness of the door in the background is juxtaposed against the colour-filled objects on the white tablecloth in the foreground. 'Make possible strong colours in the light through the proximity of black and white,' Bonnard noted in his diary entry for 4 May 1927.[20] These highly inventive colour compositions grew out of experience rather than from any theory.

The survival of the drawings for both *Coffee*, 1915 (figs.30a–c), and *The Bowl of*

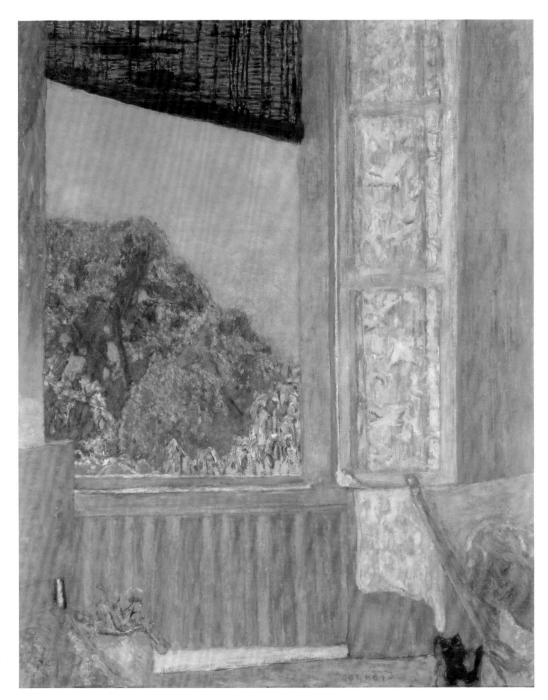

fig.28
The Open Window 1921,
oil on canvas
118 × 96 (46½ × 37¾)
The Phillips Collection,
Washington, DC

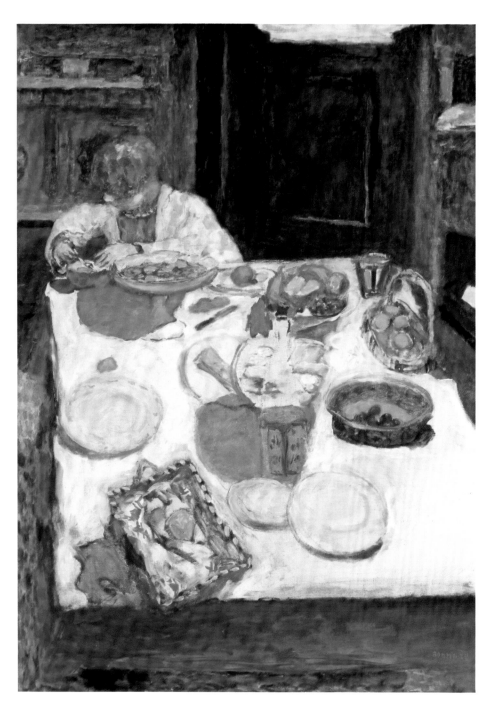

fig.29
The Table 1925,
oil on canvas
102.9 × 74.3 (40½ × 29⅜)
Tate Gallery

figs.30a–c
Preparatory drawings for *Coffee* 1915,
pencil on paper, *a* 9.6 × 13.7 (3¾ × 5⅜),
b, c 13.7 × 9.6 (5⅜ × 3¾)
Tate Gallery

Milk, 1919 (figs.31a–i), provides a rare insight into Bonnard's working procedures. Quite unlike the archetypal Impressionist painter he found it impossible to paint before the motif. Nature was endlessly distracting and colour had its own independent life, 'a logic of its own'. So these little sketches executed in a relatively blunt soft pencil played a crucial part in his working procedure: they encapsulated the essential experience from which the painting grew. It is apparent from the three drawings for *Coffee*, a compositional sketch and two studies, that Bonnard began with a simple domestic instant that caught his eye, Marthe, with her canine companion, drinking tea. This then was developed in the process of painting into a tightly structured composition within a geometric framework of balanced horizontal and vertical units, with several integrated themes: the play between surface pattern and depth, between decorative colour and *clair-obscur*, between immediacy and distance, psychological involvement and detachment. The composition was extended on the right, with the incursion of a maid serving a digestif or perhaps a draft of medicine, to balance Marthe and the dog on the left. Marthe is at the apex of a triangle, with her head turned to introduce a diagonal line leading down her nose to the bottom left-hand corner, balanced by her bent arm introducing the opposite diagonal.

Unlike Matisse who worked on one painting at a time, Bonnard would begin several contrasting subjects on a single stretch of canvas tacked to his studio wall, roughly demarcating the format for each from the outset. As the canvas underneath the frame on the left-hand edge of *Coffee* is unprimed, it was most likely the first painting on the strip.[21] Although Bonnard is generally understood to have sketched compositions in charcoal, there is no evidence of it here where the main features are drawn in very liquid tints with a brush. Marthe's head underneath the frame at the top is in a tint of alizarine red and the left-hand edge of the table in a tint of green.

Given the notoriously tentative nature of Bonnard's working procedure, there are surprisingly few pentimenti. The main changes occur where he extended the painting from the chair on the right to make way for the maid. Coloured shadows are employed in the case of the chair on the left to break up the emphatic continuous vertical of table edge and wall or in the green and blue shadows on the white crockery to integrate the background colours into the composition. Armed with a brush in one hand and a rag in the other, he would put on and wipe

figs.31a–i
Preparatory drawings for
The Bowl of Milk 1919,
pencil on paper,
a, b, g, i 12.3 × 18.1 (4⅞ × 7),
c–f, h 18.1 × 12.3 (7 × 4⅞)
Tate Gallery

fig.32
The Bowl of Milk 1919,
oil on canvas
116.2 × 121 (45¾ × 47⅝)
Tate Gallery

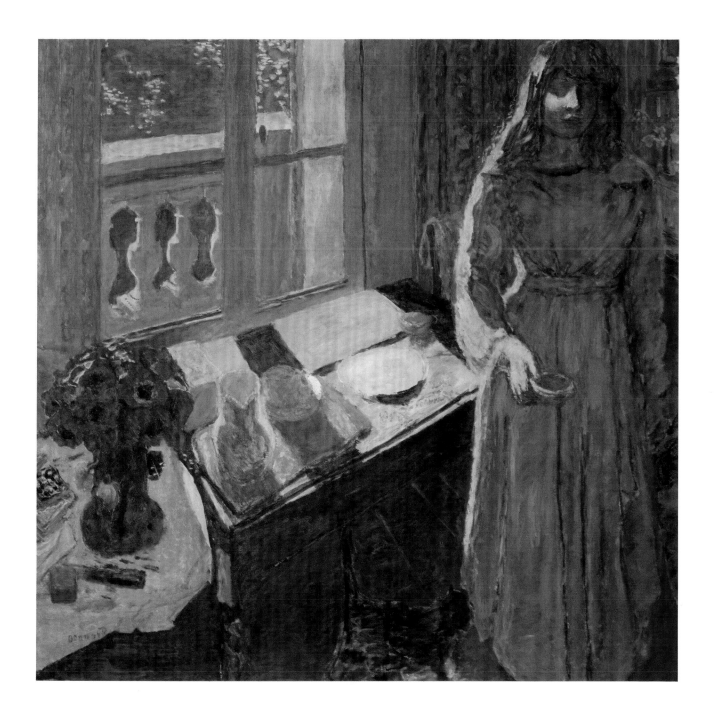

off, making constant adjustments as the subject gradually emerged from the surface. He aimed to keep the surface thin and fresh, avoiding the traditional impediments of impastoed highlights, so as to give the effect of what he described as 'a sequence of marks which join together and end up forming the object, the fragment over which the eye wanders without a hitch.'[22]

The nine drawings for *The Bowl of Milk* (figs.31a–i) show that Bonnard similarly began with a motif on the left in the light, the bunch of flowers and breakfast tray before the window, and then set out to balance it with the human element on the right in shadow, first trying a maid and a little girl about to set off with a shopping basket in a variety of poses before settling for the woman, most likely Marthe, in the process of feeding the cat. Having established the composition in the drawings Bonnard again made remarkably few changes on the actual canvas. The main elements are drawn with the brush in very liquid tints, predominantly black.

Bonnard's main efforts in the pictorial domain were geared to achieving a psychological balance between surface and depth. The drawing creates depth while the colour tends to flatten form across the surface in an atmosphere of light. The viewpoint is close and extremely high, at the woman's eye-level, tilting the objects up towards the picture plane. Placed under ultraviolet light, at approximately two feet from the ground, the painting appears much more 'realistic' and solid and the spatial reading clearer, in fact more like the drawings. Looking down over the table, the space appears to veer away from the still life on the left and then to bend round the figure of the woman on the right. Dramatic tension is created by the juggling with two distinct viewing distances: close to from above and further away from below to take in the figure of Marthe. When he came to build a studio on to his new house at Le Cannet in 1926, Bonnard had two viewing positions planned into the design, with the split levels of the small painting area in front of his 'easel' wall and the raised viewing balcony area behind it.

The surface is structured in seemingly homogeneous patterns of colour made up out of a myriad small touches which defy pigmentary analysis in their complexity. Bonnard would habitually move from canvas to canvas, applying touches of the colour on his brush, making small additions and adjustments. 'The principal subject', Bonnard maintained, 'is the surface, which has its colour, its laws over and above those of objects.'[23] His characteristic procedure became

known as 'Bonnarding'. Even when he had supposedly finished a canvas it could still go on. He had already signed his very last painting *Almond Tree in Blossom* of 1946–7 (fig.33), when he noticed that the green in the bottom left-hand corner needed a touch of yellow and too weak to do anything about it himself he got Charles Terrasse to do it for him.[24]

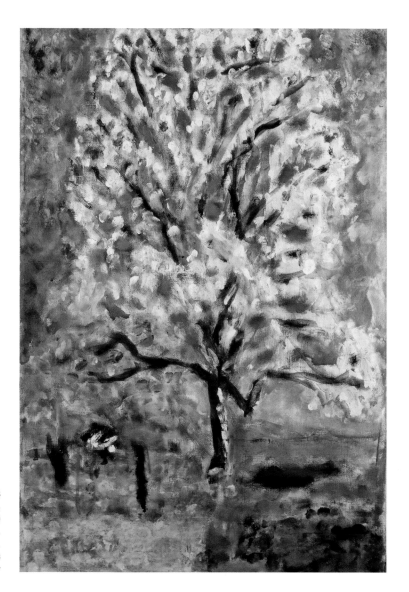

fig.33
Almond Tree in Blossom 1946–7,
oil on canvas 55 × 37.5 (21⅝ × 14¾)
Musée National d'Art Moderne,
Centre Georges Pompidou, Paris.
Dépot du Département des
Peintures du Louvre, 1977

3 The Alchemy of Light

Bonnard's breakthrough as a colourist came with the realisation that the resolution to the conflict between shadow painting and decorative colour lay in light. From the Impressionists he developed the concept of painting as the registering of his sensations of colour within an atmospheric 'envelope' of light. Forms were to be not so much modelled as modulated across the canvas surface in patterns of colour that represented the play of light. The canvas surface became a light-filled membrane. His pictures of the everyday remembered in an atmosphere of nostalgia became visionary. He evolved a complex iconology of light. Light was life, hope, memory, warmth and feeling. Towards the end of his life Bonnard told a young painter: 'Our God is light. A day will come when you will understand what that means.'[1] The alchemy of light became his goal.

In taking up where the Impressionists had left off, Bonnard placed himself in the much older tradition of Byzantine mosaics. In Byzantine mosaics The Pantokrator is often depicted with a scroll bearing the words from St John's Gospel: 'I am the light of the World'. The Byzantines conceived mosaics as a form of painting with light. The sixth-century historian Procopius described the interior of Hagia Sophia in Istanbul as 'singularly full of light and sunshine; you would declare that the place was not lighted by the sun from without, but the rays are produced within itself, such an abundance of light is poured into this church.'[2] Each tessera became a mirror reflecting the light. The gold mosaic backgrounds scatter the light and create a sumptuous, glittering surface encompassing the space in a heavenly glow.

Bonnard similarly believed in the power of colour to generate light across a surface. On his studio wall at Le Bosquet in 1946 he had pinned, along with the postcard of Seurat's *Bathers at Asnières* (then in the Tate Gallery), crumpled silver paper and old sweet wrappers, to gauge the scatter of reflected light. He found the *Bathers*, 'magnificent, the same with *The Models*', and felt that a public subscription should have been raised to keep them both in France.[3] Seurat's divisionist technique in *The Models*, 1886–8 (fig.34), is akin to a mosaic in the way that

Nude in the Bath 1936 (detail of fig.48)

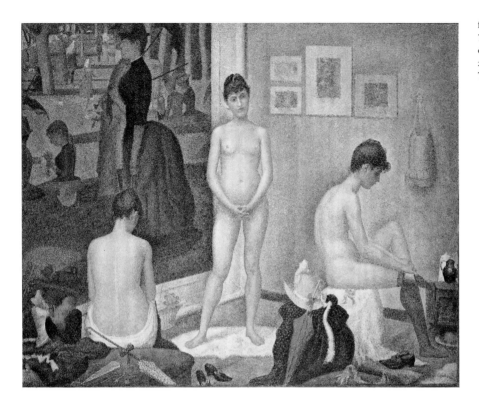

fig.34 Georges Seurat,
The Models 1886–8,
oil on canvas
200 × 250 (78¾ × 97½)
The Barnes Foundation

the surface is made up of tiny tesserae-like units imitating the play of light. *The Models* reinforced the example of Degas who introduced Bonnard to the subject of the posed nude as a suitable vehicle for the study of light.

Nude against the light

In 1907–8, when his contemporaries Matisse and Picasso, under the influence of Cézanne and African tribal sculpture, were 'carving' the nude out of colour, Bonnard approached the same subject from the opposite direction and took up the nineteenth-century challenge of establishing the nude in a light-filled atmosphere. The most durable of classical subjects was to be realised with the most transient of means. He rejected the concept of light as something external and

fig.35
The Bathroom 1908,
oil on canvas
124.5 × 109 (49 × 42⅞)
Musées Royaux des
Beaux-Arts de Belgique,
Brussels

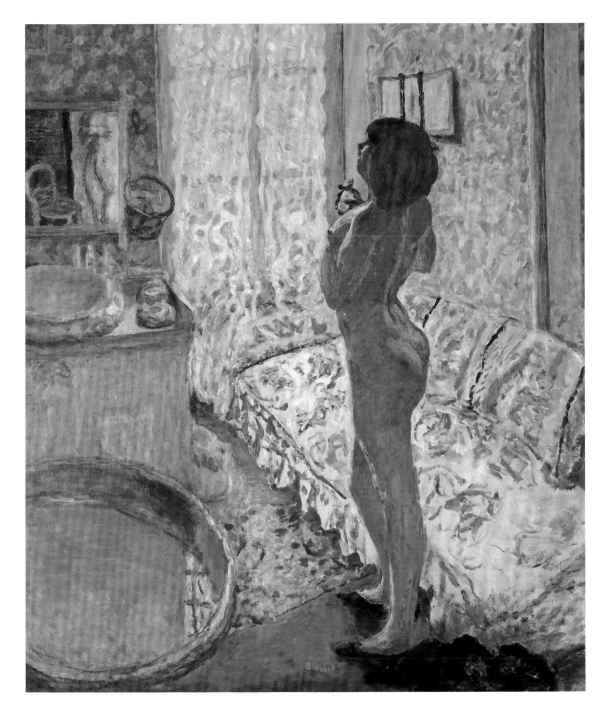

fixed and advocated a painting with light, a light that revealed objects in space and that registered feelings. Light was to be expressed not as in Fauvism by Matisse's 'harmony of intensely coloured surfaces' but by coloured patterns.

External light is brought into the interior of *The Bathroom* of 1908 (fig.35) through the swirling grey pattern of the net curtain playing against the golden ochre ground colour. The breakdown of form into pattern both defines the spatial placement of objects within the structure of the composition and at the same time creates the sensation of light flowing from the window through the composition in the changing rhythms of the surface patterns: florid and expansive across the sofa-bed, more static and concentrated on the wall behind. Things which at one moment seem fixed twitch and move. Light both models the nude against the light and at the same time denies the corporeal solidity of things. Bonnard was moving to an art of light floating between reality and a dream.

The dualism inherent in Bonnard's practice may well have derived from Seurat's Divisionist method in *The Models* of juxtaposing two colours to produce not so much a third colour, as Signac suggested, but a pearlescent haze hovering in front of the scene.[4] Fénéon listed 'a luminous vibration enlivening the scene' as one of the advantages of the Divisionist technique.[5] Through enlarging the Divisionist touches into patterns of colour, Bonnard achieved a similar but expressively more flexible range of effects without the surface vibrato.

Through the looking glass

A concomitant of Bonnard's transition from shadow painting and decorative colour to an art of light was his evolving concept of the canvas as a specular surface. The Impressionists' 'envelope' of light became a 'mirror'. He was obsessed with fluidity, by the transience of life, shadows, reflections, the changing seasons, passing passions, the shifting patterns formed by clouds, people moving along a street and by the transforming power of light. According to Dina Vierny, who posed for him after Marthe's death in 1942, he even liked his models to move around, staying silent but not still.[6] He represented life as a floating world seen through different media – through glass, through water, through mirrors – and ultimately through memory. The mirror itself became a symbol of his ambition to capture the transience of life within the contemplative silence of art.

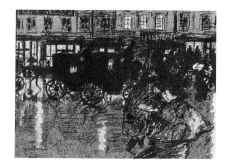

fig.36
Street at Evening, in the Rain 1896–7,
colour lithograph 30.5 × 40.6 (12 × 16),
from the album *Quelques aspects
de la vie de Paris*, 1899
The Metropolitan Museum of Art,
Harris Brisbane Dick Fund, 1928

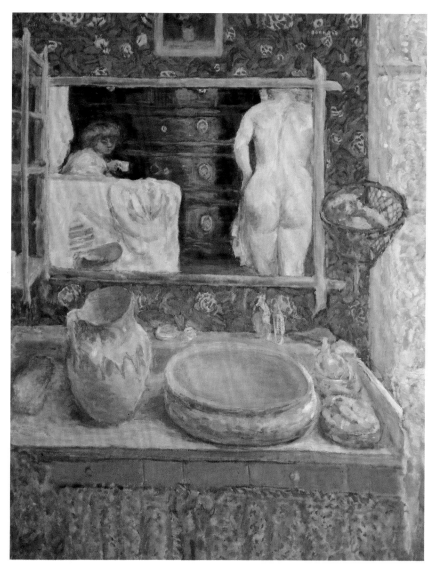

fig.37
The Bathroom Mirror 1908,
oil on panel 120 × 97 (47¼ × 38¼)
Pushkin State Museum of Fine Arts, Moscow

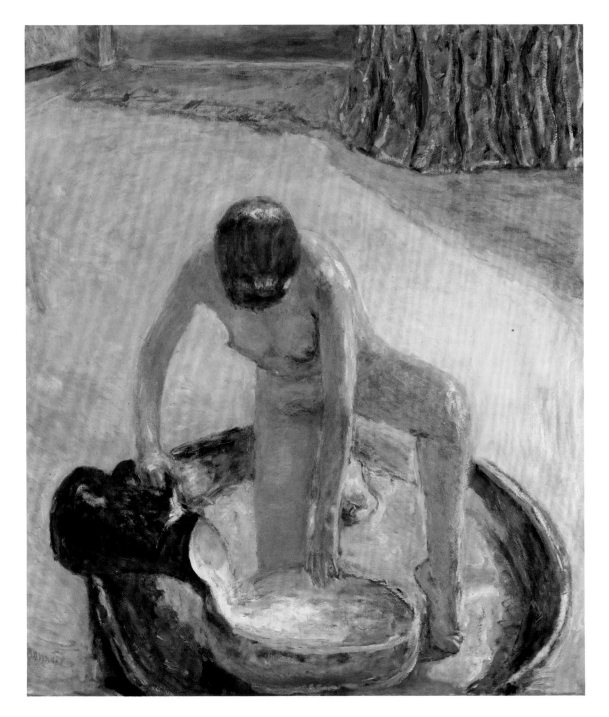

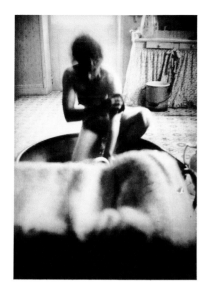

fig.38
Marthe photographed
by Bonnard, *c.*1908
Musée d'Orsay, Paris

fig.39
Nude Crouching in the Tub 1918,
oil on canvas
83 × 73 (32⅝ × 28¾)
Private Collection, Paris

Bonnard's concept of the canvas as a specular surface began in the rain-soaked streets of Paris in the 1890s. The electric light streaming through the novel plate glass windows in the coloured lithograph *Street at Evening in the Rain* of 1896–7 (fig.36) structures the horizontal movement of the shadow patterns of the traffic in a series of vertical reflections.[7] An actual mirror-view is featured in *The Bathroom Mirror* of 1908 (fig.37), a painting within the painting, as with Seurat's inclusion of a fragment of his previous painting the *Grande Jatte* in *The Models*, to open up further dimensions in space and time. The grey-on-yellow pattern of external light on the right of the composition is repeated in the nude on the right in the central mirror and then juxtaposed on the left with the alternative source of light generated by the reflection of the whites of the tablecloth, Marthe's dress and the towel against the dark chest of drawers.

A photograph by Bonnard of Marthe in a tub (fig.38) of around 1908 initiated the subject of a series of paintings which marked the further transformation of a bathroom into a chamber of light. Depth cues were removed and the tiled floor became a spectral surface. The light pouring in from a glazed door behind her in the photograph becomes, in *Nude Crouching in the Tub* of 1918 (fig.39), a torrent bearing the tub like a coracle down the golden stream. The opening up of an interior to the breadth and light of the landscape outside was the outcome of Bonnard's crucial discovery of colour in the South and his meetings with his near neighbour at his house in the North near Vernon, Claude Monet.

'The Revelation of a Thousand and One Nights': permanence versus transience

Like Matisse before him, Bonnard claimed that his breakthrough to an art of colour came with the experience of Mediterranean light at Saint-Tropez, the home of Signac, in the summer of 1909, and he had what he described as 'the revelation of a *Thousand and One Nights*: – 'the sea, the yellow wall, the reflections as full of colour as the light. After a fragrant midday meal we went to call on some neighbours and I had the vision of a very dark girl in a pink dress down to her feet with an enormous parakeet, uncaged, against the yellow, red and green background – I think I shall soon be longing for the green grass and the clouds.'[8] For Matisse and Bonnard the transition to an art of bright colour and flooding light

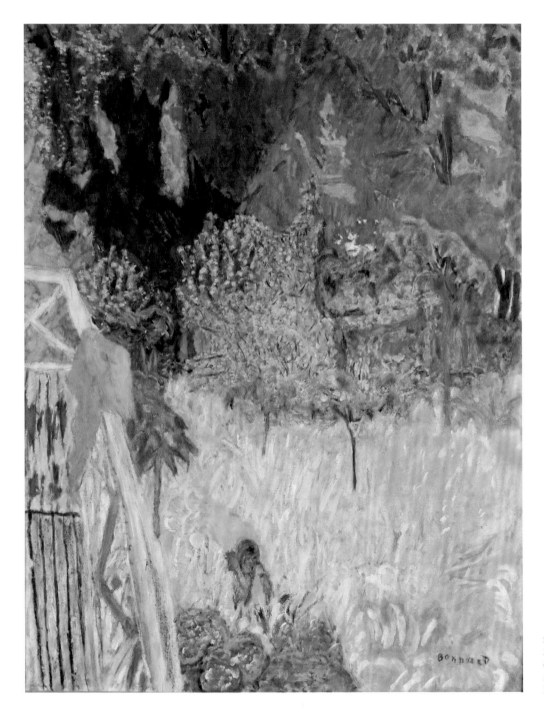

fig.40
*Balcony at Vernonnet c.*1920,
oil on canvas
100 × 78 (39⅜ × 30¾)
Musée de Brest

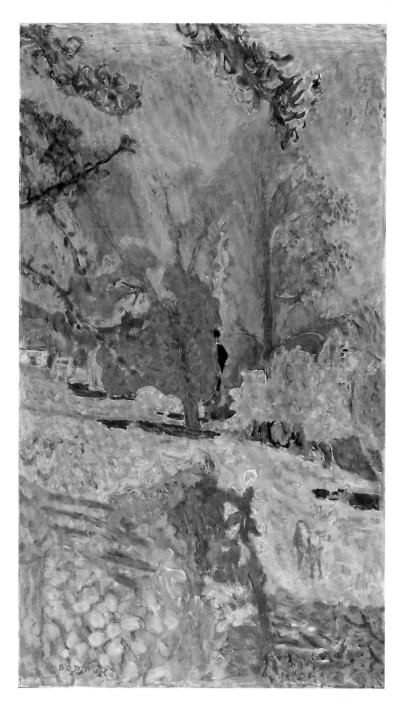

fig.41
Normandy Landscape 1920,
oil on canvas
105 × 57.9 (41⅜ × 22¾)
Musée d'Unterlinden, Colmar

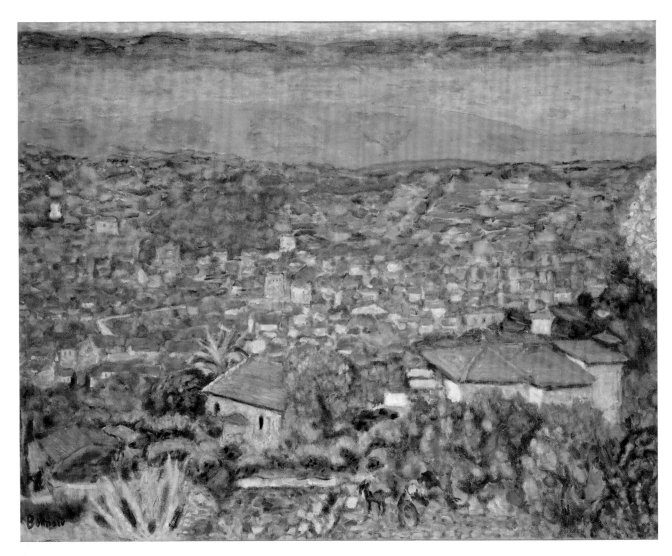

fig.42
Panoramic View of Le Cannet 1941,
oil on canvas 80 × 104 (31½ × 41)
Private Collection

had to be justified in reality and at Saint-Tropez they both encountered the conditions where reality matched the dream, the dream of an imaginary orient of the senses. More Gauguin's vision, in fact, than Signac's.

The permanence and warmth of Southern light and colour promised liberation, a kind of release into an earthly paradise, but Bonnard still hankered after green grass and the cloudy skies of the North. The contrasting appeals of Northern light and Southern light, both rooted in place with their respective cultural associations, opened up a series of dialogues in his art: between permanence and transience, classicism and Impressionism, Cézanne's way and Monet's way, and between the hot palette of the South and the cool palette of the North. Bonnard's initial solution to this dichotomy lay through Seurat who suggested a way of bridging the two traditions in an art that was both architectonic and atmospheric, classical and Impressionist, with all the permanence and structure of decorative colour and yet with the elusive subtlety of shadow painting. All these elements came together in Bonnard's *The Dining Room in the Country* of 1913 (fig.27).

And yet there was still something deeply attractive to Bonnard about Monet's version of Impressionism. In a sense Monet was the ultimate Impressionist whose method established a paradigm for the representation of the transience of nature in art. His Impressionism opened up to Bonnard a more risky path, more haphazard in its processes, and at the same time more truthful to the uncertainties of perception. Bonnard's ultimate debt to Monet lay in the belief that art began in the sensation of being overwhelmed by the beauty of nature. His day started with a ritual early morning walk during which he registered his sensations of incidents that caught his eye, sketching rapidly in a small pad secreted in his hand. These drawings later became the subject of paintings executed back in the studio. Landscape painting was central to his practice; his art, in fact, was nourished by nature.

Light is so used in Bonnard's landscapes as to convey the idea of nature as a continuum flowing beyond the confines of the framing edges. Colour does not so much describe literally as evoke the sensation of light in a system of signs. The frothy whites at the bottom of *Balcony at Vernonnet c.*1920 (fig.40) conjure up a light-filled garden, warmed by the pink of the blossom and patches of orange, within an overall vegetal tapestry. The fissures of yellow opening up the greens

and blues in *Normandy Landscape* 1920 (fig.41) capture the impression of early morning light bursting through the foliage. The pattern of pulpy pinks played out in the tiled roofs of *Panoramic View of Le Cannet*, 1941 (fig.42), his home in the South behind Cannes, fix the landscape in an incandescent glow.

From exterior to internal light

It was Bonnard's outstanding achievement to have brought the breadth and light of landscape into the interior in a succession of masterpieces, the bath paintings. On one level they are essentially nostalgic in that they recast Marthe, an ageing invalid with the medical need to wash, in the role of a youthful bather, but on a more profound level they represent one of the greatest imaginative transformations in the history of Western art. They stand as Bonnard's ultimate testament to the transforming power of light to absorb even the most durable of subjects within the expressive atmosphere of a vision.

Large Blue Nude of 1924 (fig.43) takes up the challenge set by Cézanne of realising a bather in blue, but by an alternative path. In *Blue Nude – Souvenir of Biskra* (1907) Matisse had followed Cézanne in modelling the nude solidly in colour. Bonnard by contrast establishes his bather within a blue atmosphere. Blue is a sign of shadow. The blue shadow signifies the presence of the artist and by extension that of the spectator in the painting. Bonnard uses space according to the demands of feeling: close and immediate, distant and dreamy. In *Large Yellow Nude* of 1931 (fig.44) Bonnard changes the key from blue to a pervasive yellow atmosphere, the colour of a golden age, a distant memory of happiness.[9]

Despite their seeming accessibility, the bath paintings are not necessarily easy to read. Part of Bonnard's achievement was to persuade the spectator of the 'naturalness' of his vision in which the everyday is presented in totally unexpected ways. Without consciously feeling manipulated, we are drawn into the unfolding logic of a painting and ideas from one painting are taken up and developed in another. In *The Bath* of 1925 (fig.45) the colour has been drained from the flesh tones leaving the bather as a corpse stretched out within the rigid geometry of a watery grave. In *Nude in the Bath*, also of 1925 (fig.46), the bath with the pearly pink lower half of the bather is brought up to the picture plane and juxtaposed with the colourful surrounds. White and colour therefore stand as alternative

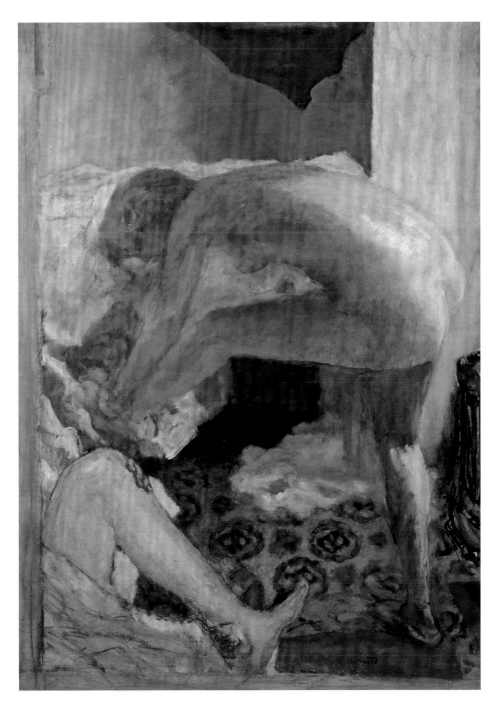

fig.43
Large Blue Nude 1924,
oil on canvas
101 × 73 (39¾ × 28¾)
Private Collection, courtesy
Galerie Bernheim-Jeune, Paris

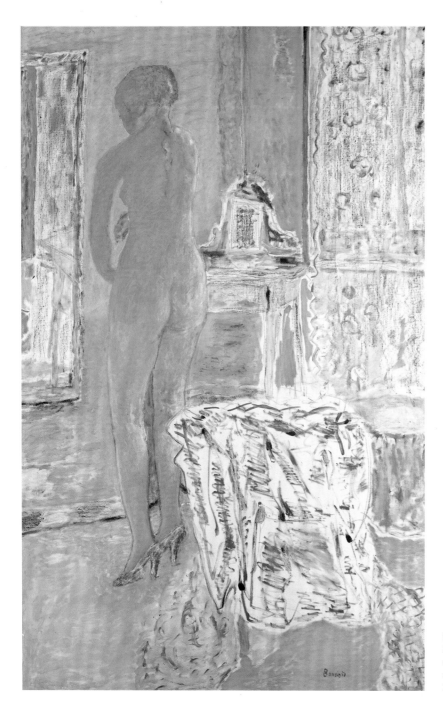

fig.44
Large Yellow Nude 1931,
oil on canvas
170 × 107.3 (66⅞ × 42¼)
Private Collection

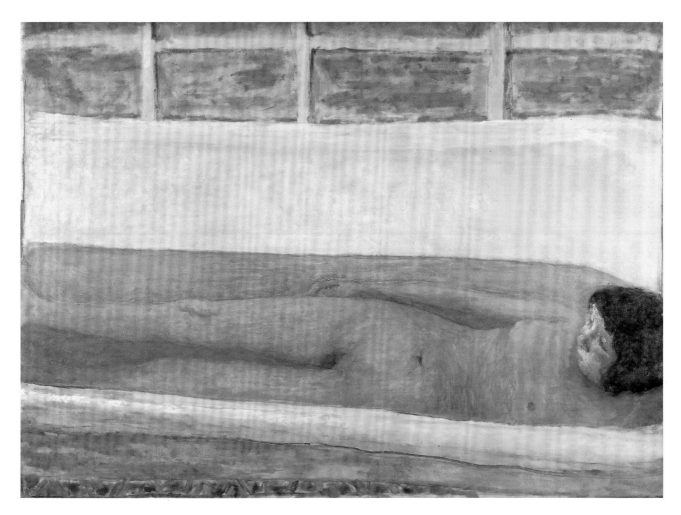

fig.45
The Bath 1925,
oil on canvas
86 × 120 (33⅞ × 47¼)
Tate Gallery

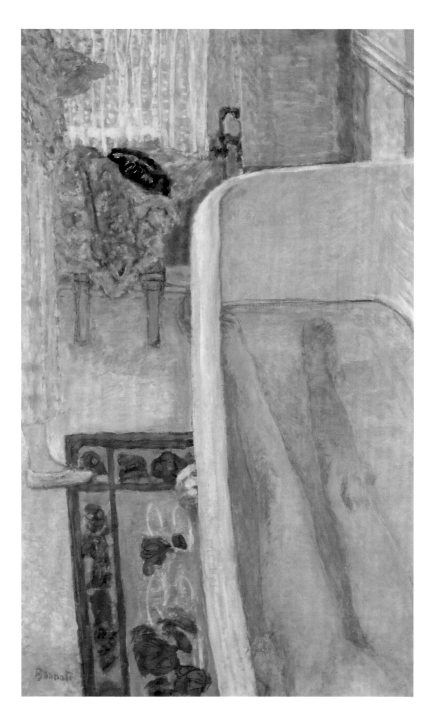

fig.46
Nude in the Bath 1925,
oil on canvas
103 × 64 (40½ × 25¼)
Private Collection

signs of light. 'Proximity of white making patches of colour luminous', Bonnard wrote in his diary on 16 April 1927.[10] Light and colour are brought together in a decorative art derived from nature.

It is one of the ironies of history that Bonnard, along with Impressionism, the first movement to have recognised the importance of light, should have been marginalised in the twentieth century by the triumph of Cubism, as essentially superficial and somehow caught up in registering surface appearances, even though Einstein posited in 1905 that light played the central role in the new understanding of space and time.[11] While probably unaware of the latest scientific developments, Bonnard pursued a parallel path of discovery. He stepped through the looking glass into an ostensibly phenomenological world defined by light, operating in space and time, and mediated through memory and feeling.

The camera lucida

In 1927 Bonnard and Marthe moved into Le Bosquet, the house at Le Cannet which he had bought the previous year, and then added a studio, a garage and a bathroom. This small tiled bathroom (fig.47), his *camera lucida*, became the final setting for the metamorphosis of form through light. Light strikes the north wall behind the bath from three sides: the French windows on the east, the window behind the bidet on the south and the open door to the small sitting room on the west. Bonnard treated the tiled north wall as a specular surface, a kind of screen, to register the transforming power of light, and it became for him in his last years the equivalent of the surface of Monet's water lily pond at Giverny. Such specular surfaces produce intense and mobile highlights which tend to retain the hue of the light source rather than those of reflecting objects.[12] Bonnard wove the time-space-feeling process into vision by registering continuities and discontinuities of luminance across the canvas surface.

From the myriad reflections, re-reflections, shading and shadows caused by the passing of light, Bonnard would isolate and develop a theme. In the glorious *Nude in the Bath* of 1936 (fig.48) the light source becomes a golden stream competing with the enhanced blue of the floor tiles and shadows for the possession of Marthe, a Titianesque Danaë figure, irradiated by her bath with nuggets of golden light falling like drops of water onto the blue floor. Suspended in time, she is

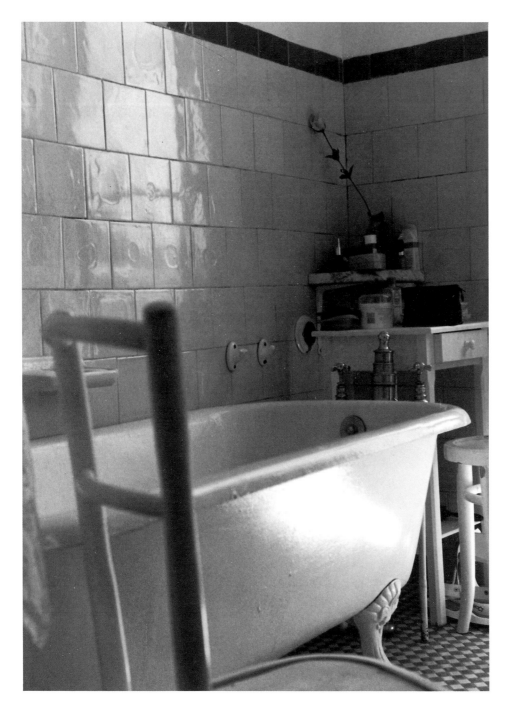

fig.47
The bathroom at Le Bosquet

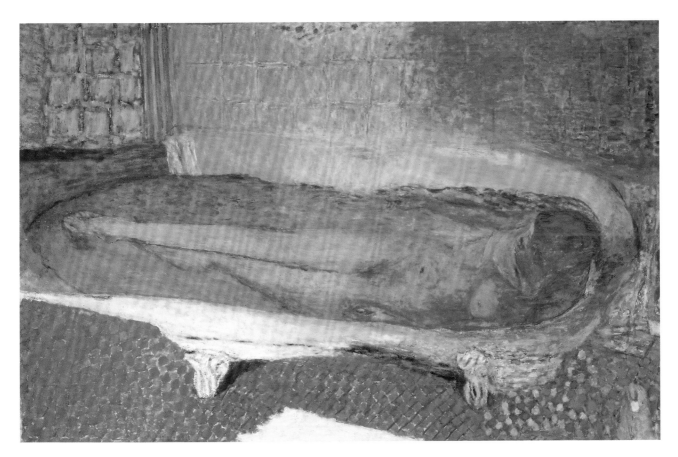

fig.48
Nude in the Bath 1936,
oil on canvas
93 × 147 (36⅝ × 57⅞)
Musée d'Art Moderne
de la Ville de Paris

taken outside time and becomes eternal. Space is created in the transition from one fixed point to another. The spectator is established in the painting above Marthe's breasts, which are glimpsed through light refracted in the bathwater below, and the surrounding space is bent round her body which trails away to the left. The close viewpoint is one of possession, and yet she remains distant, as though reflected in a surface of mother-of-pearl.

Nude in the Bath and Small Dog of 1941–6 (fig.49), the last masterpiece in the series, was begun the year before Marthe's death in 1942 and completed the year before Bonnard's own death in 1947. It is a poignant painting. The bath, reminiscent of a coffin, is respectfully withdrawn in space. The little dog guards against too close an intrusion on the scene. The colours are heated up and Marthe is in the process of being consumed by the light. The enclosing space buckles and heaves in agitated patterns of colour.

In the transition to a light-filled mirror space, Bonnard stepped out of the protective darkness of shadowlands to confront himself. The ultimate source of his painting did not now lie outside himself but within. Painting was the product of an emotion or feeling which found its subject-matter in the world outside, as he explained to Pierre Courthion: 'I believe that when you are young, it is the object, the outside world that inspires you: you are totally absorbed. Later, it is the internal, the need to express an emotion that drives the painter to choose such and such a starting point, such and such a form.'[13] Left alone in Le Bosquet after Marthe's death, he came to terms with himself in a final series of self-portraits. The resulting paintings are harrowing. *Self-Portrait in the Bathroom Mirror* of 1943–6 (fig.50) reveals a lonely monk-like figure with shaven head and naked torso humbly accepting his fate.

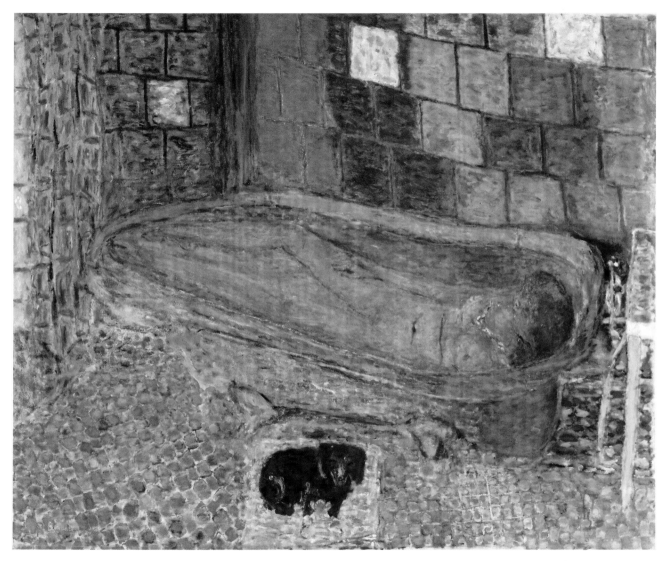

fig.49
Nude in the Bath and Small Dog
1941–6, oil on canvas
121.9 × 151.1 (48 × 59½)
Carnegie Museum of Art,
Pittsburgh. Acquired through
the generosity of the Sarah
Mellon Scaife family

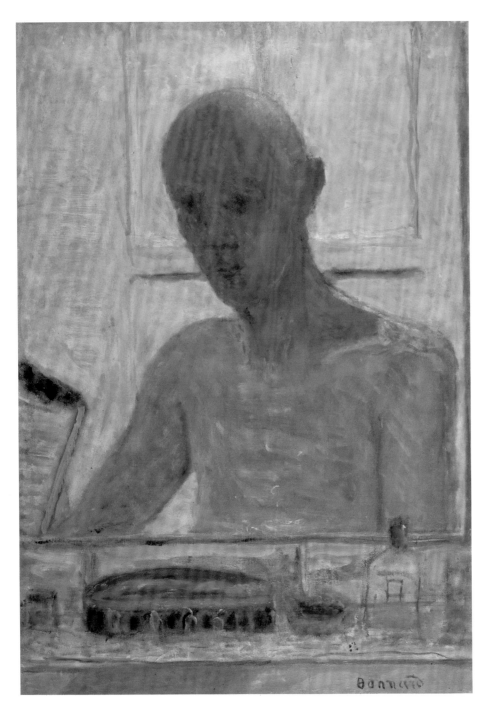

fig.50
Self-Portrait in the Bathroom Mirror
1943–6, oil on canvas
73 × 51 (28¾ × 20⅛)
Musée National d'Art Moderne,
Centre Georges Pompidou, Paris.
Dation (Ancienne Collection
Florence Gould) 1984

Notes

Introduction

1 Raymond Cogniat, *Bonnard*, New York 1968, p.30.
2 Françoise Gilot and Carlton Lake, *Life with Picasso*, Harmondsworth 1966, p.264.

Chapter 1

1 Charles M. Blanc, *Grammaire des arts du dessin*, Paris 1867, p.583.
2 Pliny the Elder, *Natural History*, xxv, 43, in Victor I. Stoichita, *A Short History of the Shadow*, trans. Anne-Marie Glasheen, London 1997, p.11.
3 E.H. Gombrich, *Shadows: The Depiction of Cast Shadows in Western Art*, exh.cat., National Gallery, London 1995, pp.17–19.
4 John Gage, *Colour and Culture*, London 1992, p.135.
5 Michael Baxandall, *Shadows and Enlightenment*, New Haven and London 1995, pp.17–31.
6 Gauguin, letter to Emile Bernard, 14 August 1888, in Herschell B. Chipp, *Theories of Modern Art*, Los Angeles and London 1968, p.60.
7 John Gage 1992, p.135, n.4.
8 Charles Terrasse, *Bonnard*, Paris 1927.
9 Baxandall 1995, p.5, n.5.
10 Stoichita 1997, pp.103–10.
11 Charles Baudelaire, 'Le Peintre de la vie moderne', *Ecrits sur l'art*, II, p.176 in Stoichita 1997, n.2, p.106.
12 Nicholas Watkins, *Bonnard*, London 1994, pp.25, 29.
13 The fashion for silhouette entertainments had enjoyed a long history in France, since their introduction from China, perhaps via Japanese shadow puppets in the eighteenth century; the word itself derived from a pun about Louis XV's Minister of Finance, Etienne de Silhouette. See Stoichita 1997, n.2, p.155.
14 Michel Melot, *L'Oeuil qui rit*, Friburg 1975, pp.103–4.
15 Henry Havard, *La Décoration*, 6th ed., Paris 1894(?), p.19.
16 Watkins 1994, n.12, p.34.
17 Pliny the Elder, in Stoichita, 1997 n.2, p.153.
18 Watkins 1994, n.12, p.186.

Chapter 2

1 Maurice Denis, *Journal*, Paris 1899, quoted in Gloria Groom, *Edouard Vuillard: Painter-Decorator*, New Haven and London 1993, pp.121, 123.
2 Ingrid Rydbeck, 'Nos Bonnard i Deauville 1937', *Konstrevy*, Stockholm 1937. Trans. Anne-Marie Kelsted.
3 John Gage 1992, p.63, n.4.
4 Antoine Terrasse, *Pierre Bonnard*, Paris 1967, p.122.
5 'Pierre Bonnard nous écrit', *Comoedia*, Samedi 10 avril 1943.
6 Maurice Denis, 'L'Influence de Paul Gauguin', *L'Occident*, October 1903.
7 Groom 1993, p.89, n.1.
8 Gaston Diehl, *Bonnard*, Paris 1943.
9 Ibid.
10 Ursula Perucchi-Petri, *Die Nabis und Japan. Das Fruhwerk von Bonnard, Vuillard und Denis*, Munich 1976, p.71.
11 M.E. Chevreul, *De la loi simultané des couleurs*, Paris 1839.
12 Seurat's copy of Rood's Contrast Diagram reproduced in William Innes Homer, *Seurat and the Science of Painting*, Cambridge, Mass., 1964, p.41.
13 Rydbeck 1937, n.2.
14 Anthony Hartley, ed., *Mallarmé*, Harmondsworth 1965, p.17.
15 Apollinaire, *Les Fenêtres*, trans. in John Richardson, *A Life of Picasso 1907–1917: The Painter of Modern Life*, London 1996, p.219.
16 Nicholas Watkins, 1994, p.139.
17 P. Signac, *D'Eugène Delacroix au Néo-Impressionisme*, Paris 1899, reprinted Françoise Cachin, ed., Paris 1964, p.82.
18 *Bonnard/Matisse Correspondance*, presented by Jean Clair and Antoine Terrasse, Paris 1991, pp.9–10.
19 André Giverny, 'Bonnard', *La France libre*, 6, no.31, 15 May 1943, p.59.
20 Sasha M. Newman, ed., *Bonnard*, New York and London 1984, p.69.
21 I am grateful to Roy Perry for enabling me to examine the painting with him in the Conservation Department of the Tate Gallery.
22 Michel Terrasse, *Bonnard at Le Cannet*, London 1988, p.9.
23 'Les Notes de Bonnard' published in *Bonnard*, Paris 1984, p.191.
24 Charles Terrasse, 'L'Amandier en fleur de Bonnard', *La Revue du Louvre et des musées de France*, 14, no.3, 1964, p.144.

Chapter 3

1 John Rewald, *Pierre Bonnard*, New York 1948, p.57.
2 Liz James, *Light and Colour in Byzantine Art*, Oxford 1996, p.5.
3 Jules Joets, 'Deux Grands Peintres au Cannet', *Art-Documents*, no.29, February 1953, p.9.
4 Signac 1899, p.69.
5 Félix Fénéon, *L'Emancipation sociale*, Narbonne 3 April 1887, in *Au de la de l'impressionisme*, Paris 1966, pp.84–5.
6 Annie Pérez, 'Entretien avec Dina Vierny', in *Pierre Bonnard*, Les Grands Expositions, Beaux-Arts Magazine, Paris 1984.
7 Colta Ives, Helen Giambruni, Sasha M. Newman, *Pierre Bonnard. The Graphic Art*, The Metropolitan Museum of Art, New York 1989, p.130.
8 Annette Vaillant, *Bonnard*, London 1966, p.115.
9 It is interesting to note that Young and Helmholtz demonstrated that white light could be reconstituted from just yellow and blue wavelengths. Gage 1992, p.174.
10 'Les Notes de Bonnard', 1984, p.182.
11 Malcom Longair, 'Light and Colour', in Trevor Lamb and Janine Bourriau, eds., *Colour: Art and Science*, Cambridge 1995, p.97.
12 Baxandall 1995, p.8.
13 Pierre Courthion in Antoine Terrasse, *Pierre Bonnard*, Paris 1988, p.166.

A Brief Chronology

1867
3 October Born at Fontenay-aux-Roses, a suburb of
Paris, son of Eugène Bonnard, the senior career civil
servant at the Ministry of War, and Elisabeth Bonnard,
née Mertzdorff, from Alsace. Childhood spent at
Fontenay-aux-Roses and at Le Grand-Lemps, their
family home in the country in Isère, near Grenoble.

1885
Passes his baccalaureate and enrols in the Faculty of
Law.

1887
While pursuing his law studies, attends classes at the
Académie Julian where he meets Paul Sérusier,
Maurice Denis, Gabriel Ibels and Paul Ranson.

1888
July Passes his law degree.
October Paul Sérusier returns from seeing Gauguin in
Brittany and shows to his friends Bonnard, Denis, Ibels
and Ranson *The Talisman*, his painting produced under
the supervision of Gauguin, and they decide to form
themselves into a group, called the Nabis, from the
Hebrew word for a prophet.

1889
Begins part-time work in the Registry Office and is
accepted by the Ecole des Beaux-Arts where he meets
Edouard Vuillard and Ker-Xavier Roussel. Rents his
first studio.
June The Nabis are profoundly impressed by the
Gauguin exhibition at the Café Volpini in the precincts
of the Universal Exhibition.

1890
Leaves the Registry Office to work for the Public
Prosecutor of the Seine region. Deeply moved by the
exhibition of Japanese prints at the Ecole des Beaux-
Arts. Military service at Bourgoin.

1891
March Exhibits for first time at the Salon des
Indépendants. His poster *France-Champagne* appears on
the streets of Paris.
December Participates in first exhibiton of the Nabis.

1893
Meets Maria Boursin, Marthe (1869–1942), his lifelong
companion whom he marries in 1925.

1895
22 November Death of his father.

1900
Begins to work each spring and summer in the Seine
valley, the late summer and autumn at Le Grand-
Lemps and the winter in Paris.

1901
January Visits Spain with Vuillard and Emmanuel
Bibesco.

1902
May Visits Holland with Vuillard and Roussel.

1905
Over the next five years makes frequent short trips
abroad, visiting Belgium, Holland and England.

1906
February Travels via Marseilles and Toulon to stay with Maillol at Banyuls.
9–20 November First of many one-man exhibitions at Bernheim-Jeune which becomes his gallery.

1908
Visits Algeria and Tunisia.

1909
June–July Stays at Saint-Tropez, his first lengthy sojourn in the South.

1912
Buys Ma Roulotte, his house outside Vernonnet, near Vernon, on the Seine.

1913
May–June Travels to Hamburg with Vuillard.

1919
16 March Mother dies.

1921
March Spends fifteen days in Rome.

1925
Marries Marthe.

1926
27 February Buys house at Le Cannet which he calls Le Bosquet.
September Travels to the United States to sit on the jury of the Carnegie International Exhibition in Pittsburgh.

1927
Publication of Charles Terrasse's monograph on Bonnard.

1939
Last visits to Normandy. Spends the war at Le Bosquet.

1940
21 June Death of Vuillard at La Baule.

1942
26 January Death of Marthe.

1947
23 January Death of Bonnard at Le Bosquet.

Select Bibliography

Catalogues raisonnés

Bouvet, Francis, *Bonnard. L'Oeuvre gravé*, Paris 1981; English edition, *Bonnard. The Complete Graphic Work*, trans. Jane Brenton, New York and London 1981.

Dauberville, Jean and Henry, *Bonnard: Catalogue raisonné de l'oeuvre peint*, 4 vols., Paris 1965–74.

Heilbrun, Françoise, and Néagu, Philippe, *Pierre Bonnard photographe*, Paris 1987.

Terrasse, Antoine, *Bonnard illustrateur: Catalogue raisonné*, Paris 1988; English edition, *Pierre Bonnard, Illustrator*, trans. Jean-Marie Clarke, New York 1989.

Books, Exhibition Catalogues and Journals

Baxandall, Michael, *Shadows and Enlightenment*, New Haven and London 1995.

Bell, Clive, *Bonnard-Vuillard*, exh. cat., Royal Scottish Academy, Edinburgh 1948.

Bell, Julian, *Bonnard*, London 1994.

Blanc, Charles M., *Grammaire des arts du dessin*, Paris 1867.

Blume, Mary, *Cote d'Azur. Inventing the French Riviera*, London 1992.

Bonnard, Pierre, 'Pierre Bonnard nous écrit', *Comoedia*, 10 April 1943.

Bonnard, Pierre, *Correspondances*, Paris 1944.

Bonnard, exh. cat., Centre Georges Pompidou, Musée National d'Art Moderne, Paris 1984.

Bonnard/Matisse Correspondance, presented by Jean Clair and Anoine Terrasse, Paris, 1991.

Bonnard at Le Bosquet, exh. cat., Hayward Gallery, London and Laing art Gallery, Newcastle 1994.

Brassaï, *The Artists of My Life*, London 1982.

Callen, Anthea, *Techniques of the Impressionists*, London 1982.

Chevreul, M.E., *De la loi simultané des couleurs*, Paris 1839.

Chipp, Herschell B., *Theories of Modern Art*, Los Angeles and London 1968.

Cogeval, Guy, *Bonnard*, Paris 1993.

Cogniat, Raymond, *Bonnard*, Paris, 1968; English edition, New York 1968.

Denis, Maurice, 'L'Influence de Paul Gauguin', *L'Occident*, October 1903.

Fénéon, Félix, *Au delà de l'impressionisme*, ed. Françoise Cachin, Paris 1966.

Flam, Jack D., *Matisse on Art*, London 1973.

Frèches-Thory, Claire, and Terrasse, Antoine, *The Nabis*, Paris 1990.

Gage, John, *Colour and Culture*, London 1992.

Giambruni, Helen Emery, *Early Bonnard, 1885–1900*, PhD dissertation, University of California, Berkeley 1983.

Gilot, Françoise, and Lake, Carlton, *Life with Picasso*, Harmondsworth 1966.

Giverny, André, 'Bonnard', *La France libre*, 6, no.31, 15 May 1943, pp.57–61.

Gombrich, E.H., *Shadows. The Depiction of Cast Shadows in Western Art*, exh. cat., National Gallery, London 1995.

Groom, Gloria, *Edouard Vuillard: Painter-Decorator*, New Haven and London 1993.

Havard, Henri, *La Décoration*, 6th ed., Paris 1894.

Hartley, Anthony, (ed.), *Mallarmé*, Harmondsworth 1965.

Heron, Patrick, *The Changing Forms of Art*, London 1955.

Homer, William Innes, *Seurat and the Science of Painting*, Cambridge, Mass. 1964.

Hyman, Timothy, *Bonnard*, London 1998.

Ives, Colta, Giambruni, Helen, and Newman, Sasha M., *Pierre Bonnard: The Graphic Art*, exh. cat., The Metropolitan Museum of Art, New York 1989.

James, Liz, *Light and Colour in Byzantine Art*, Oxford 1966.

Joets, Jules, 'Deux Grands Peintres au Cannet', *Art-Documents*, no.29, February 1953.

Lamb, Trevor, and Bourriau, Janine, (eds.), *Colour: Art and Science*, Cambridge 1995.

Lhote, André, *Bonnard. Seize peintures 1894–1946*, Paris 1948.

Mann, Sargy, *Drawings by Bonnard*, exh. cat., Nottingham 1984.

Mann, Sargy, *Bonnard Drawings*, London 1991.

Melot, Michel, *L'Oeuil qui rit*, Friburg 1975.

Nabis 1888–1900, exh. cat., Kunstaus, Zürich, Galeries nationales du Grand Palais, Paris 1993–4.

Natanson, Thadée, *Le Bonnard que je propose 1867–1947*, Geneva 1951.

Newman, Sasha, (ed.), *Bonnard*, New York and London 1984.

Pérez, Annie, 'Entretiens avec Dina Vierny', in *Pierre Bonnard*, Les Grandes Expositions, Beaux-Arts Magazine, Paris 1984.

Perucchi-Petri, Ursula, *Die Nabis und Japan. Das Fruhwerk von Bonnard, Vuillard und Denis*, Munich 1976.

Rewald, John, *Pierre Bonnard*, exh. cat., The Museum of Modern Art, New York, in collaboration with The Cleveland Museum of Art 1948.

Richardson, John, *A Life of Picasso 1907–1917: The Painter of Modern Life*, London 1996.

Roger-Marx, Claude, *Bonnard*, Paris 1950.

Roger-Marx, *Bonnard lithographe*, Monte Carlo 1952.

Credits

Rydbeck, Ingrid, 'Hos Bonnard i Deauville', *Konstrevy*, 13, no.4, Stockholm 1937.

Signac, Paul in Françoise Cachin, (ed.), *D'Eugène Delacroix au Néo-Impressionisme*, Paris 1899, reprinted Paris 1964.

Soby, James Thrall, et al., *Bonnard and His Environment*, exh. cat., The Museum of Modern Art, New York 1964.

Stoichita, Victor I., *A Short History of the Shadow*, trans. Anne-Marie Glasheen 1997.

Sutton, Denys, *Pierre Bonnard, 1867–1947*, exh. cat., Royal Academy, 1966.

Terrasse, Antoine, *Pierre Bonnard*, Paris 1967, rev. ed., Paris 1988.

Terrasse, Charles, *Bonnard*, Paris 1927.

Terrasse, Michel, *Bonnard at Le Cannet*, London 1988.

Terrasse, Michel, *Bonnard du dessin au tableau*, Paris 1996.

Tucker, Paul Hayes, *Monet in the '90s. The Series Paintings*, Museum of Fine Arts, Boston, New Haven and Yale 1989.

Vaillant, Annette, *Bonnard*, Neuchâtel, 1965; English ed., London 1966.

Watkins, Nicholas, *Matisse*, Oxford 1984.

Watkins, Nicholas, *Bonnard*, London 1994, 1996.

Zervos, Christian, 'Pierre Bonnard est-il un grand peintre?', *Cahiers d'art*, 22, 1947, pp.1–6.

Copyright Credits

Photographic Credits

© 1998 The Art Institute of Chicago, Photo: Greg Williams 17, 23

The Barnes Foundation 34

Carnegie Museum of Art, Pittsburgh 49

Galerie Bernheim-Jeune, Paris 43

Richard L. Feigen and Co, New York 15

The Fine Art Society plc 10

The Flint Institute of Arts 9

Jane Voorhees Zimmerli Art Museum, Photo: Victor Pustai 19

© Alexander Liberman 18

© 1984 The Metropolitan Museum of Art, New York 20

© 1985 The Metropolitan Museum of Art, New York 36

© 1988 The Metropolitan Museum of Art, New York 7

The Mineapolis Institute of Arts 27

Musée d'Art Moderne de la Ville de Paris 48

Musée d'Orsay, Paris 38

Musée d'Unterlinden, Colmar, Photo: O. Zimmerman 41

Musée National d'Art Moderne, Centre Georges Pompidou, Paris 50

Musées Royaux des Beaux-Arts de Belgique, Brussels 35

The Museum of Modern Art, New York frontispiece, back cover

National Gallery of Art, Washington, Photo: Richard Carafelli 6

National Gallery of Scotland 3, 5

National Gallery, London 12

The Philips Collection, Washington DC 28

Photo: Jim Strong, New York 26

Private Collection 1, 12, 16, 21, 39, 42, 44

Pushkin State Museum of Fine Arts, Moscow 37

Réunion des Musées Nationaux, Paris, Photos: Arnaudet, Gérard Blot and Hervé Lewandowski 2, 4, 8, 11, 24, 40, 48, 50

Spadem-ADAG 14, 38

Tate Gallery, London, Photos: Marcella Leith, Marcus Leith 22, 29, 30, 31, 32, 45

The Trustees of the Victoria and Albert Museum 13

Nicholas Watkins 47

Index